Fantastic Realms!

Draw Fantasy Characters, Creatures and Settings

V Shane

IMPACT

CINCINNATI, OHIO

www.impact-books.com

ABOUT THE AUTHOR

V Shane has worked as a full-time freelance illustrator in the fields of science fiction and fantasy role-playing games, comics, and game and novel covers for nearly fourteen years. Usually involved in more than one genre at a time, Shane applies pencils, inks, watercolor, airbrush, oils and digital mediums to a vast array of projects for gaming companies and movie production studios. Recently, he has focused his strengths in the comic-book world to help elevate sword-and-sorcery and high-fantasy comic illustration to greater visibility. Shane maintains a website at www.wacomknight.com, where you can experience more of his mainstream work, get information and updates about new projects and pick up art tips. You can also contact him by e-mail at v_shane@indiemail.com.

Published by IMPACT Books, an imprint of F+W Publications, Inc., 4700 East Galbraith Road, Cincinnati, Ohio 45236. (800) 289-0963. First Edition.

Other fine IMPACT books are available from your local bookstore, art supply store or direct from the publisher.

10 09 08 07 06 5 4 3 2 1

DISTRIBUTED IN CANADA BY FRASER DIRECT
100 Armstrong Avenue
Georgetown, ON, Canada L7G 5S4
Tel: (905) 877-4411

DISTRIBUTED IN THE U.K. AND EUROPE BY DAVID & CHARLES
Brunel House, Newton Abbot, Devon, TQ12 4PU, England
Tel: (+44) 1626 323200, Fax: (+44) 1626 323319
Email: mail@davidandcharles.co.uk

DISTRIBUTED IN AUSTRALIA BY CAPRICORN LINK
P.O. Box 704, S. Windsor NSW, 2756 Australia
Tel: (02) 4577-3555

Library of Congress Cataloging in Publication Data
Shane, V., 1964-
 Fantastic realms : draw fantasy characters, creatures and settings / V Shane.
 p. cm.
 Includes index.
 ISBN-13 978-1-58180-682-3 (pbk. : alk. paper)
 ISBN-10 1-58180-682-5 (pbk. : alk. paper)
 1. Fantasy fiction--Illustrations. 2. Fantasy in art. 3. Drawing--Technique. I. Title.
 NC961.7.F36S53 2006
 743'.87--dc22

 2005019329

Edited by Mona Michael
Designed by Wendy Dunning
Production art by Donna Cozatchy
Production coordinated by Mark Griffin and Matt Wagner

Metric Conversion Chart

To convert	to	multiply by
Inches	Centimeters	2.54
Centimeters	Inches	0.4
Feet	Centimeters	30.5
Centimeters	Feet	0.03
Yards	Meters	0.9
Meters	Yards	1.1

DEDICATION

To my lifetime companion and wife, Julia, and our increasingly creative daughter, Jade. Their support, love and appreciation for my work mean a great deal to me and help sustain my sanity and love of life. Also a very deep thank you to the universe at large, which has inspired us and continues to guide our family's dreams.

ACKNOWLEDGMENTS

I want to give big thanks to those who inspired, helped and worked with me over the many years in illustration:

Barry Windsor-Smith, Michael Kaluta, Bernie Wrightson, Mobius, John Byrne, Andrew Loomis and especially Mike Grell have been my inspirations. These people made major impacts on how I dealt with creating the art and page layout of the fantasy comic book.

Special appreciation to my editor, Mona Michael, for her thoroughness and wonderful spirit to keep me on track. Also to my fellow fantasy art friends and writers to whom I go for advice, help and just plain critiques about my art: Christopher Heath, Chris Kucharski, Andrew Goldhawk, Tom Bisogno (Ice Pond Studio), Alan Pollack, April Lee, Randy Asplund, Quinton Hoover, Dario Carrasco and all at Digital Webbing and Illustrationet.

And a definite huge thank you to Michael Whelan for his kindness and color guidance.

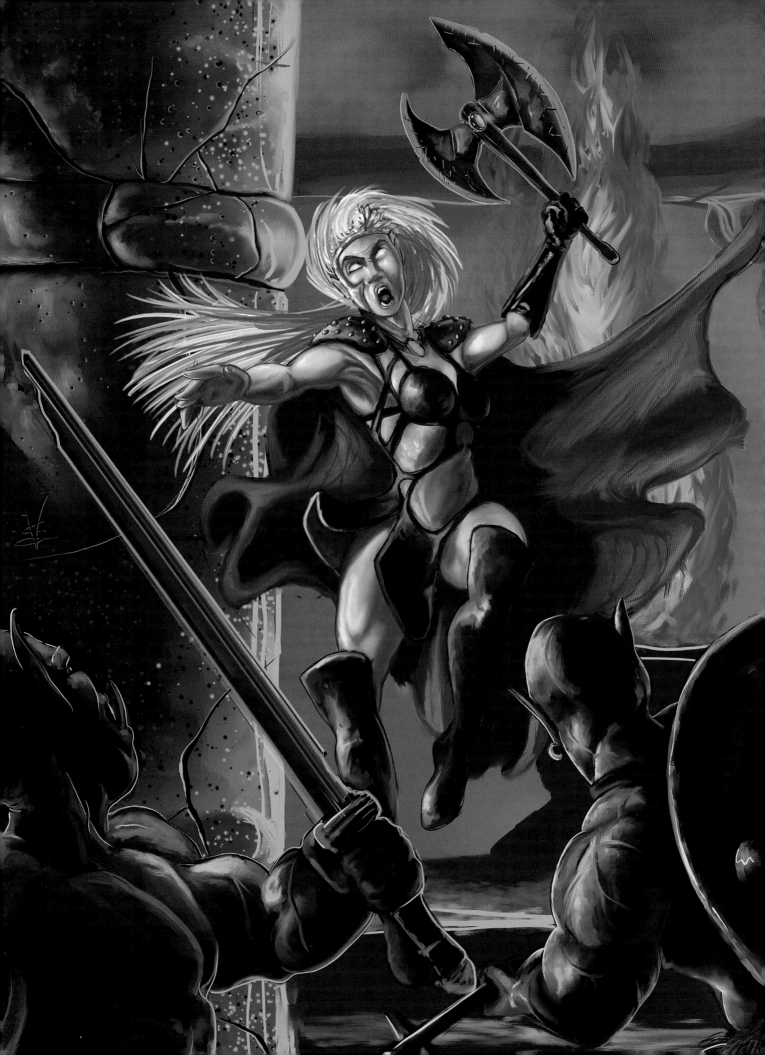

Table of Contents

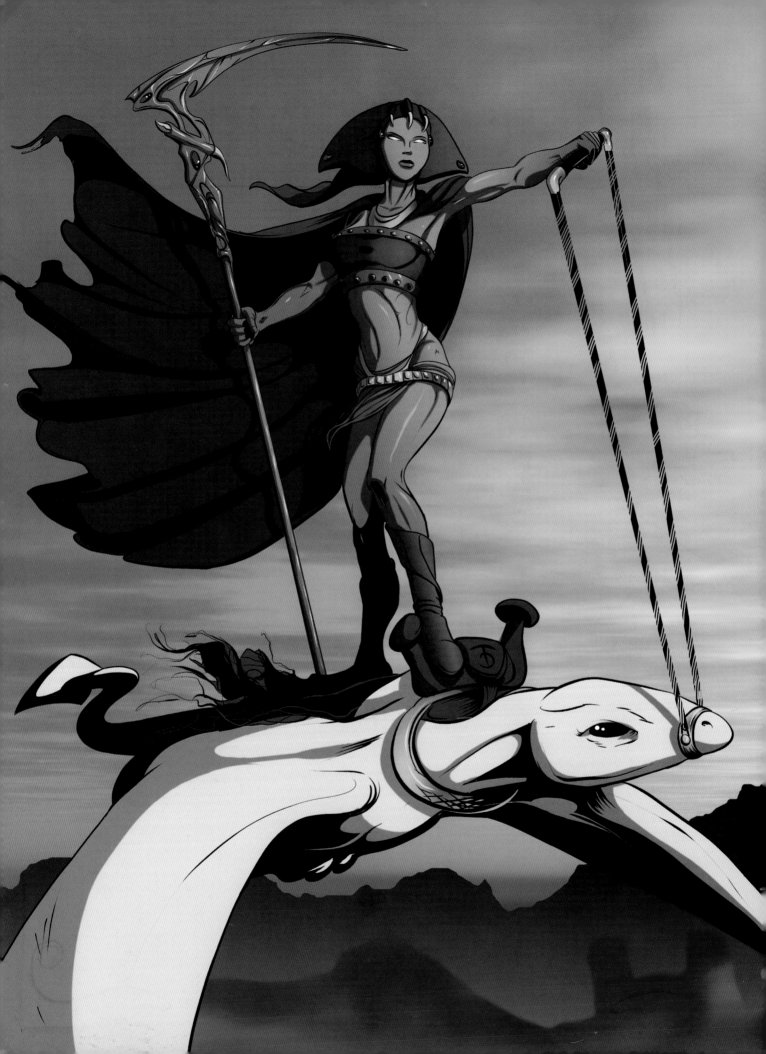

The Quest Begins!

Once upon a time … Words from books, stories and myths conjure images in our heads that play out in our imaginations. Sometimes it's the words that inspire us to first pick up a pencil: we want to artistically express the pictures the words evoke. Other times we are inspired by our own stories. Through the pages that follow, you'll learn to create fantastic worlds on paper, no matter where the ideas come from.

Knowing how to turn your imagination into art is a powerful ability. And while the contents herein deal exclusively with the fantasy genre, the techniques can be applied to any genre and used to enhance any fine-art discipline. You'll strengthen your sketching and drawing skills to greatly improve your work.

Now let's create a new world—or an ancient one!

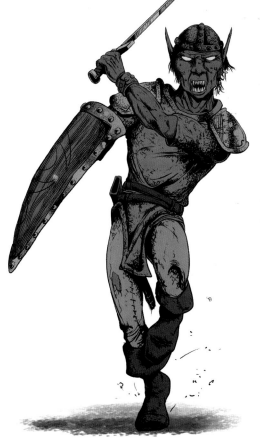

BEGIN WITH SEEING

Learning to carefully observe the forms around you will allow you to see a world full of fabulous creatures, where others only see a cabinet of knickknacks and dust bunnies. The unorganized clutter that most people have in their rooms at one time or another can be a gateway to temples, ancient ruins or the lairs of foul beasts.

Once you begin to really see, you'll notice the variety of light, shadow and texture surrounding you, too. When you learn to replicate that light, shadow and texture, you'll be able to draw anything.

Prepare to See Light and Shadow
Close your eyes and think about picking out solid grays and black shapes of shadow, like buildings in a crowded downtown area. Then open your eyes, *slowly*, and you'll begin to see how the shadows around you connect to reinforce location of the main source of light. Then sketch!

Keep Mechanical Pencils Handy

Mechanical pencils are great for traveling and spontaneous sketching. You never have to worry about breaking the point because the lead can be advanced if you do. And no sharpening!

The Short, Short List of Supplies

You will probably need more than this eventually, but this little list will get you started as a designer of vast worlds and an architect of the mind's eye.

- ➤ *Quiet time (little to no distraction)*
- ➤ *Music*
- ➤ *Paper*
- ➤ *Pencil*
- ➤ *Eraser*

USE AVAILABLE REFERENCES

O nce you begin really seeing the world around you, you're likely to get hungry for more images. Most of the time you can find what you need nearby; however, sometimes you may need a good look at a yak, for instance. So where can you find one?

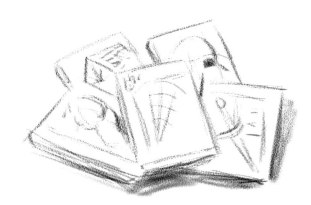

Use Reference Photos

You can find a reference photo for just about anything on the Internet. That's where image search engines come in handy. Also consider 3-D programs such as 3D Canvas, 4D Blue, Anim8or, Art of Illusion, Breeze Designer and many others. They can take basic shapes and help you visualize scenes and figures. Do a web search for free 3D programs.

Visit the Library

Book and magazine references are always good. If the book images are too small, use your scanner like a magnifying glass to get a better look at details you might miss. Be careful though; it's easy to get lost in books and get nothing done.

Use Your Friends

Take pictures of your friends and family for references. Several art books featuring the famous fantasy illustrators the Hildebrandt Brothers, in particular, show them using likenesses of friends and family members in their book covers.

Feeling Inspired?

Never wait for inspiration. Waiting to be inspired can waste a lot of good drawing time. (Turn to Appendix II Creation Lists to Get You Started on page 122 for a good way to get your ideas rolling.)

GET IDEAS FROM ORDINARY OBJECTS

Everything around you has a story, or can become part of a story. Amazing ideas often come together suddenly when you glance randomly at something or someone. With practice, you can develop these unexpected impressions into stories of your own.

Experiment With Halloween Costumes and Masks

Dress up with mismatched parts. Imagine ninja weapons with a Dracula cloak, a wolf mask and dinosaur-feet shoes.

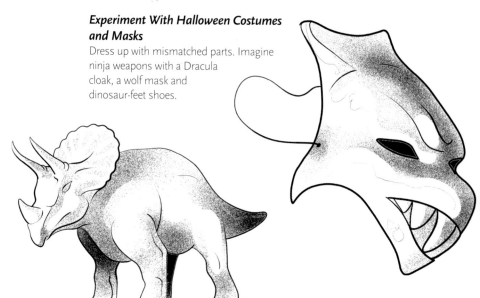

Investigate Toys

Dinosaurs, mainstream TV cartoon action figures, comic book action figures—the combination possibilities are huge. Combine at least three different toys in any drawing.

Find Inspiration in the Kitchen and Closets

Kitchen items, cleaning items and appliances make good references for machinery and strange-looking buildings.

Study Insects

Look for ideas to sprout from bugs, beetles and arachnids! Nearly every movie creature has its origins in some kind of bug. Even some aerodynamic armor designs come directly from beetle casings.

Go Outside

There are a lot of really bizarre things in nature. Use them to feed your imagination. Roots are my personal favorite; I use them to dream up everything from wicked creatures with tentacles to evil, overgrown ruins. Mushrooms, in particular, are fascinating because of their varied shapes outside of the "store brand" you see here. In the wild, they look likes vast half-sphere cities to shelter homes for small or large creatures, depending on the size of your mushroom.

Ordinary Patterns Can Become Extraordinary Ideas

Have you noticed that when you look at something for a long time, it starts to look funny? Squint at things such as wood grain, crack patterns in sidewalks, mountains, clouds and carpet—either low pile or high shag. You'll begin to see them in a different way. Begin sketching as the objects begin to look different.

Try the same thing with other objects, patterns, shadows and even people. The longer you stare, the more ideas they will generate.

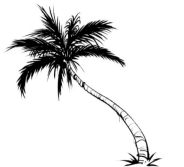
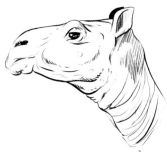
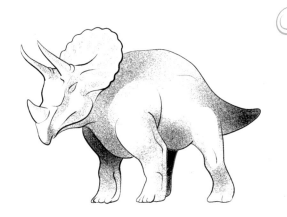

Create New Creatures From Unrelated Elements

Three unrelated objects can be combined to make something entirely different. A vacation postcard lying on my kitchen counter caught my eye while my daughter played with her toy dinosaurs and watched a cartoon that took place in the desert. So, suddenly the fronds of the palm tree reminded me of fur or hair. I found myself taken with this camel's head. And the triceratops's three horns and powerful squat demanded attention.

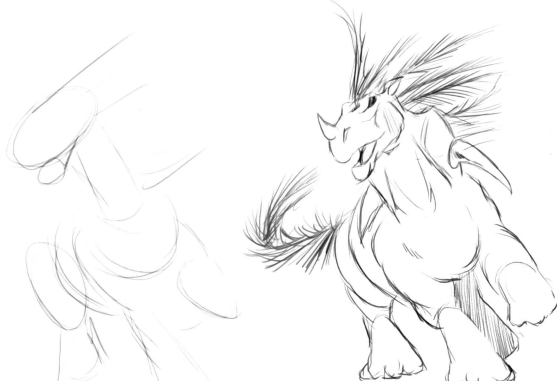

Sketch Your Initial Combination

Do a rough sketch of your ideas. Here, the head of the camel replaces the head of the triceratops. I didn't want to lose the coolness of the head plate or the horns, so I regrouped the features.

Before You Combine Objects

Ask yourself the following questions about each object you're referencing in your drawing:
➤ What is each object's strongest feature?
➤ How can I apply that feature to my drawing?

Differentiate Your New Creature From Its References

The camel and the triceratops are often drawn standing still. This creature is charging the viewer. This gives the palm fronds a chance to flutter in the wind and identifies this guy as his own being!

GET IDEAS FROM ABSTRACT FORMS

Ideas, states of being and concepts are all described as being *abstract*. Forms, too, can be abstract when they can't be identified as predefined persons, places or things.

Sometimes the only way out of a creative rut is to experiment with the loosely defined world of abstract forms. From them, you can often come up with realistic, yet fantastic ideas.

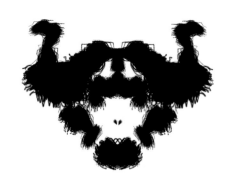

Create Your Own Ink Blots

The Rorschach test is controversial in the psychology field. It measures your psychological state based on your interpretation of a specific series of ink blots. We won't worry about what Rorschach ink blots may say about your mind, but creating your own ink blots can help generate lots of new ideas (especially with wet paint of different colors).

Fold a piece of paper in half. On one side of the fold apply a bunch of different blotches of paint and/or ink. Refold the blank half over the blotches. Firmly press the two sides together, then pull them apart. As you examine the result, turn it to various angles.

Play With Clay

Work some clay in your hands. Try to not to think of any specific object as you begin to mold the clay. Follow your instincts as a form takes shape. Once you've finished, do some quick sketches of your creation.

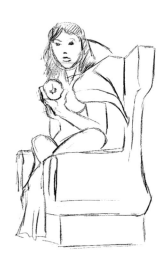

Random Sketches Can Turn Into Drawings

Sitting at a mall one day, I scribbled out a little something on a blank notepad. Later, I rotated it around until I saw something in the sketch. In this case, I saw a sorceress sitting cross-legged in a chair—or maybe a type of throne. She is holding a crystal ball.

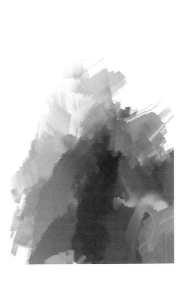

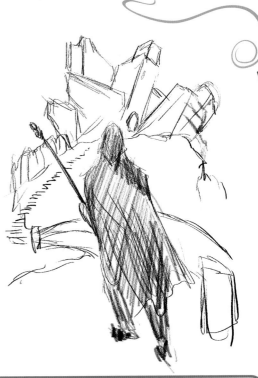

Turn Random Paint Strokes Into Scenes

You can use any kind of paint to do this, but acrylics work best, especially if you use an *extender medium* that makes the paint dry more slowly and gives you more time to add and mix color. In this case, I used a *monochromatic* palette (different shades of a single color). I used the darker brown sparingly and added white while stirring with a brush. Once the paint dried, I came back to the design with nothing in mind and started to sketch. I isolated an area that reminded me of a wanderer approaching a ruined city.

It's a good idea to prepare a bunch of abstract paint sheets at once. Then you can put them in a folder and take them with you to parks or wherever you happen to be going. It's not unusual for me to get several drawings from a single sheet.

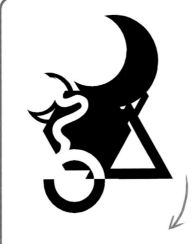

Join Random Shapes

Use paper or cardboard cutouts, magnets or a basic paint program to join shapes together. Once you have something that looks interesting, rotate the image to activate your imagination.

Mine turned into a high priestess. I moved the circle to the center so it became a crystal. And the crescent became a horn. Maybe she lives in that ruined city, eh?

Draw Silhouettes

Arrange several large everyday items such as those mentioned on page 10 in a group. With the lights off, place a flashlight behind your collection. You can look at the arrangement directly, or use the flashlight to project its shadow onto the wall. Either way, be careful to use enough light so you don't stumble over things and risk making a huge mess and noise in the dark. Oh, and never use candles; they flicker too much and can be dangerous if knocked over.

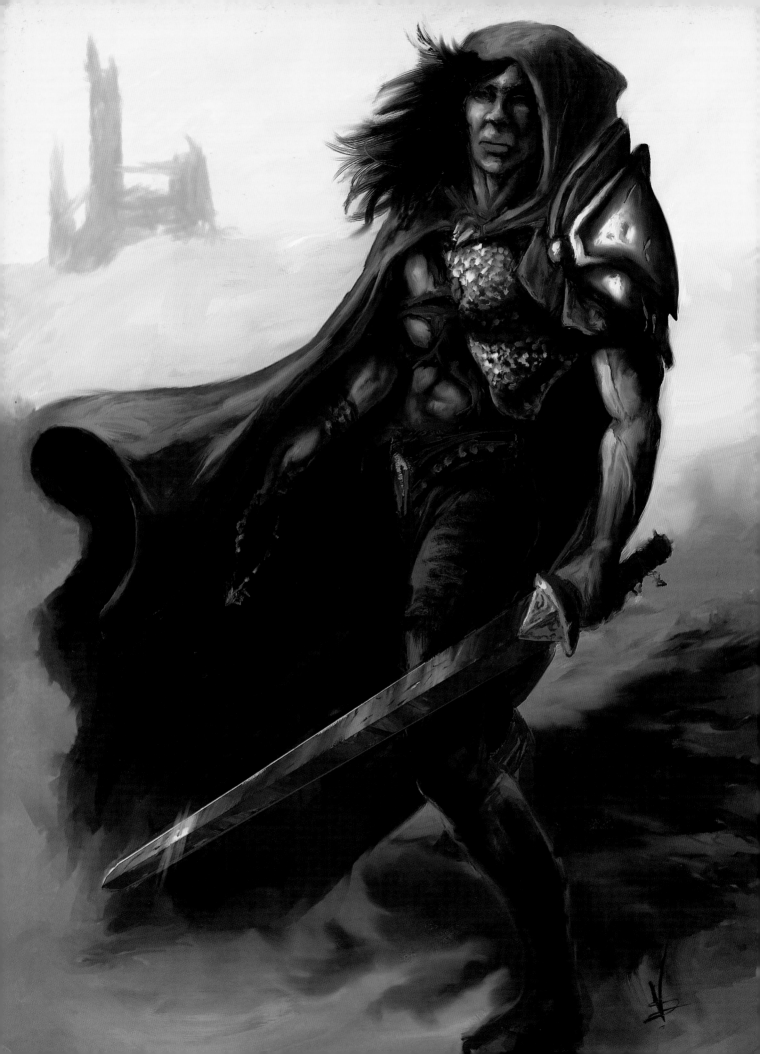

Basic Sketching and Drawing

Just like adventurers getting ready to go on a quest, artists must prepare themselves before setting out to create fantasy worlds and creatures. All art, no matter what the medium or genre, begins with basic drawing supplies and skills. As you master these, you'll start to expand your arsenal of tools and techniques. There is no "right" way. Everyone finds a different path to their visions. This chapter simply shows you where to begin. Where you travel from here is up to you.

WHAT TO PACK

Adventurers are well advised not to load their packs with extraneous baubles. Some of the best and most efficient supplies are the simple ones: paper, pencils, erasers and ink pens. You'll be surprised at how many creatures you can bring to life in your world with only the basics.

Keep It S.I.M.P.L.E

This is all you need to get started:

SKETCH PAD. *Any fine art pad will do for initial concepts.*

INK PEN OR BRUSH. *I recommend a Hunt 102 crow quill pen and a fine sable no. 2 round brush. Ask your art supplier.*

MATERIAL TO INK ON. *Surfaces such as posterboard or art board.*

PENCILS. *You'll need a variety of grades: HB, 2H, 2B, 3B.*

LIGHT SOURCE. *Candles are dangerous; light bulbs are much better!*

ERASERS. *You'll need a kneaded eraser and a white eraser.*

Erasers
Use kneaded erasers for controlled erasing in small areas, white for erasing larger areas.

Sketchbooks
Book-style sketchbooks are easy to store, keep everything organized, and are a great way to create volumes of your ideas. Date your sketchbooks so you can quickly find that sketch you did last night *or* last summer.

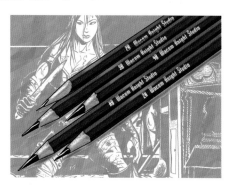

Brushes
You can find brushes in all sizes, from very small, hairline sizes of 000, 00 and 0 all the way up to 3 and 4. Larger brushes aren't as useful for illustration.

Posterboards and Art Boards
Look for heavy bristol board or 2- or 4-ply art boards with smooth or vellum surfaces.

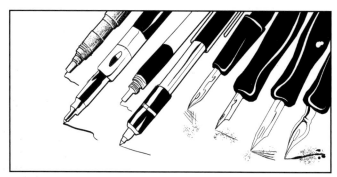

Ink Pens
Different pens work for different jobs. Quills are good for fine detail and quick hatching without saturating the paper as markers do. Technical pens are also great for detail and preferable for use with a straightedge or geometric templates. Markers work for filling in larger areas or doing thick borders with templates.

Pencils
HB is the standard "classroom" pencil and very usable for most surfaces. If you go further into the "H" series though, the lead gets very hard. The harder lead is, the lighter it becomes. I prefer the "B" series for all my illustrations.

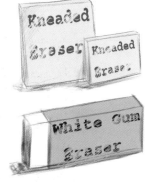

ADDITIONAL SUPPLIES THAT COME IN HANDY

Once you've got your pack loaded with the basic supplies, you can start browsing the art store for things that are just nice to have on hand.

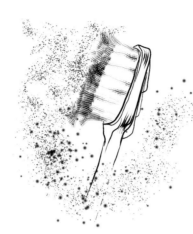

Transparent Pica Ruler

You'll often need a straightedge or ruler for the drawing of straight lines and measuring. While a regular ruler will sometimes do the job, a transparent pica ruler allows you to see underneath it. Look in the drafting section of art stores. It's brilliant for perspective and easily drawing the correct sword width.

Recycled Items

Almost anything can become an art tool to create cool effects. An old toothbrush is invaluable as an ink spattering tool for small areas.

Clay

Okay, so maybe you don't need clay for sketching. But it's handy as a tool for sculpting basic forms to give yourself a 3-D model to work from.

Portfolio

Portfolios are great for travel and storage for your art. If you spend just a little extra, you can get one that's waterproof.

Inking Materials

Inking is an art all its own, so it takes some practice to become adept. As you improve, you'll figure out which materials you like best. Here are some typical items you'll find useful.

> ➤ *Art board*
> ➤ *Crow quill pen points and holders*
> ➤ *India ink*
> ➤ *India ink markers or artist pens*
> ➤ *Sable no. 2 round brush*
> ➤ *Straightedge*
> ➤ *Technical ink pen*
> ➤ *White correction pen*

Wastebasket

Eraser residue and pencil shavings tend to build up. Be kind; don't brush them on the floor!

SKETCHING AND SHADING TECHNIQUES

having an arsenal of sketching and shading techniques will help you quickly define textures in your art and separate planes of depth for both the viewer and you.

Hatching
Quick wrist flicks with a technical pen or quill help add texture and form.

Crosshatching
A bit more organized than hatching, with crosshatching you create a pattern of straight and crisscrossed lines. Draw the lines closer together and/or thicker in shadows and farther apart and/or thinner as you approach the light source.

Pointillism
Apply a series of random dots in a circular fashion to give the illusion of smooth gradations. Form dots that are close together in the shadows and farther apart as you get closer to the light source. Use a technical pen or a felt-tipped marker.

Scattered Crosshatching
Work in a circular pattern, but use a series of quick hand-drawn lines. Use a technical pen or a quill.

Contour Lines
Use a line brush with a steady hand (it takes practice) or even a technical pen with a template. Contour lines generally have an even line weight and do not vary.

Wear Headphones While You Draw

Add music to your list of must-haves. Go ahead and put it on. Headphones are great to help you focus and lock out distractions.

Dagger Strokes
These are the mainstay of the comic book world. They work best with a fine, well-loaded brush. Apply an even amount of pressure to the brush as you drag it across the surface. When you get to the end of your predetermined stroke length, gradually lift the brush from the surface letting the very tip trail briefly on the surface in a quick stroke/lift.

Stringlike Strokes
These are ideal for use with a technical pen. Just allow the weight of the pen in your hand to guide the back-and-forth motion of the lines.

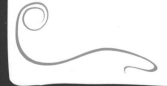

BASIC MOTIONS OF SKETCHING

In order to create the shading necessary for believable drawings, you need to get your hand accustomed to some basic motions. Like any other skill, these require practice to master. You want your hand to become used to different angles of sketching without having to turn your paper in circles. Since you'll do most idea sketches with small strokes on 8½" × 11" (22cm × 28cm) sheets of standard paper, your wrist and fingers need to be nimble.

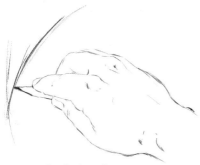

Covering Large Areas

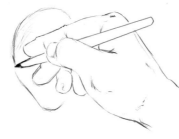

Roughing or Refining

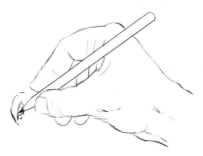

Detailing

Holding Your Drawing Tool

The most effective way to hold your drawing tool will depend on the type of work you're doing. Covering large areas, for example, merits wide strokes and allows a looser grip on the pencil. When you need more control for details such as eyes, hold the pencil close to the point. Experiment to figure out what is comfortable for you.

Use Sweeping Circles for Figure Contours

Practice these circles (reverse the direction if you're left-handed) to improve the fluidity and flow of your sketching. It's important to relax as you create your initial ideas. Sweeping circles are particularly important for human and animal contours. See page 31 for an idea of what you can do with this stroke.

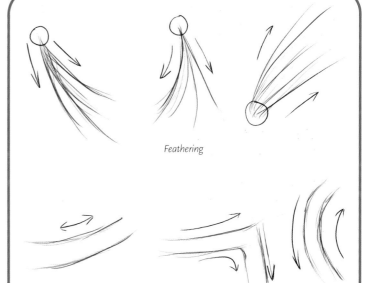

Feathering

Bar Sweeps

Feathering and Bar Sweeps

You'll use feathering and bar sweeps for clothing and drapery. Try the strokes from every direction, allowing overlapping lines that will later assist you in defining the flow of the clothing over the figure. The bar sweeps are also good for sketching belts, straps and various types of armor. See pages 34–37 to see the sort of things you can do with these.

SKETCH TECHNIQUES FOR COMMON TEXTURES

You'll use the same basic techniques to create most textures. Just decide where your light source is, then shade in the shadows. On this page are the common textures that you'll use in the drawing demonstrations throughout and in many of your own drawings. As you work through the demonstrations, you'll see swatches like these next to finished drawings to help you see which textures go where. Practice duplicating these swatches. They will give you a solid foundation from which to build your own textures, too!

Leather
Scattered crosshatching is useful for creating the look of leather.

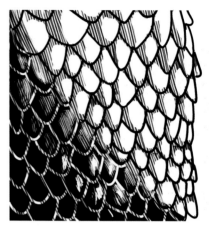

Scale Mail
Combine contour lines and hatching for scale mail, lizard scales and even stone walls.

Polished Metal
Contour lines and pointillism together make excellent polished metal.

Chain Mail or Scale Mail Seen from a Distance
There's nothing like these little U-shapes for representing chain and scale mail from far off. This is another case where it's good to use India ink and white acrylic paint or a white correction pen.

Use Solid Blacks For Metal

Look at a stainless steel teaspoon. You should see lots of very dark darks. Metal is a combination of deep darks and harsh highlights. For this reason, you can most effectively represent metal with solid blacks. India ink provides the blackest black available. Having white correction fluid or paint handy will allow you to recapture any lost highlights.

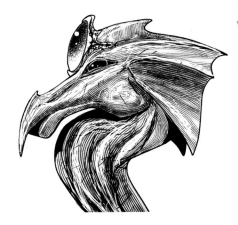

Smooth Stones

Alternate between crosshatching and pointillism to create smoother stones. A technical pen and India ink are great for this, but fine-tipped markers will work, too.

Faceted Precious Gems

Make dagger strokes with a technical pen or fine-tipped marker and a straightedge for the shape of the stone and all the hard edges. For the refractions where the light reflects, use shorter dagger strokes.

Natural, Aged and Carved Wood

Make long stringlike strokes with a crow quill pen or fine-tipped marker for the wood grain. Maintain the contour of the wood, going with the grain.

Fur

Hair

Grass

Fur, Hair and Grass

Use light dagger strokes or flowing contour lines for fur, hair and grass.

Start a Texture Sketchbook

A texture sketchbook will give you a quick reference point each time you draw. Begin developing yours with the techniques shown here, then add your own ideas and techniques as you discover them. I have folders with pages of experimental pen-and-ink techniques I developed for myself and they have come in very handy through the years.

START WITH BASIC SHAPES

Even the most complex drawing begins with simple shapes. Picture all your drawings as shapes as you develop them.

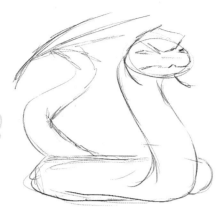

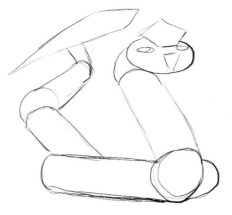

Begin With Seed Sketches

Whenever you begin a new drawing, you'll want to start with seed sketches made up of basic shapes and lines. These will help you work out the overall layout of your character or scene before you spend a lot of time on it.

Seed Sketch Defines Your Overall Picture
Quick sketches made up of basic shapes help you work out your ideas.

The Serpent is Composed of a Series of Cylinders
Once you have your idea and basic pose down, simplify your subject by figuring out more specifically what shapes you're dealing with.

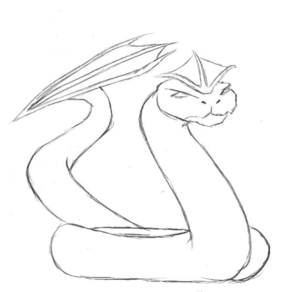

Develop Outline Drawings From Basic Shapes
Basic shapes help you work out things such as foreshortening and perspective for your outline drawings.

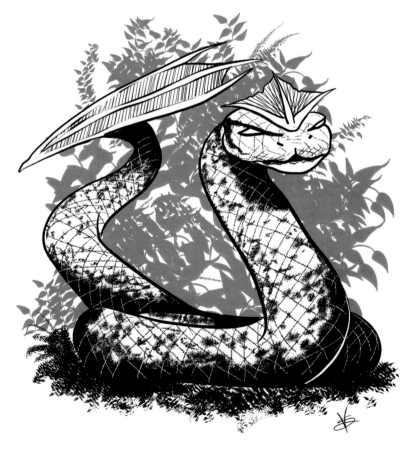

Texture and Shading Give the Shapes Form
With a solid outline drawing, you need only add textures, highlights and shadows to develop a fully-rendered creation.

CREATE FORM WITH LIGHT AND SHADOW

You know that everything, no matter how complicated it seems, is made up of basic shapes. So how do you give those shapes form to make them look three-dimensional? To do that you need to understand how light affects 3-D forms and how to represent its effects on paper.

There are a few different types of light. *Ambient light* is multidirectional, often coming from more than one source. It's what you normally experience outside, in classrooms and shopping malls. It adds very little drama or excitement to a piece of art and makes it more difficult to see form and texture. *Direct light* generally comes from one source, such as a lamp, and shines directly at your subject. It is best for showing the form and texture of whatever you're drawing because it allows you to see deep shadows and bright highlights. It also creates *reflected light*, which is light's reflection from the ground into the shadow area of an object.

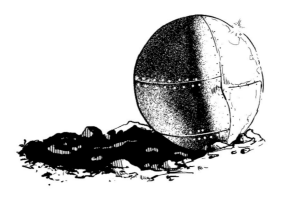

Light and Shadow Create a Sphere
When light strikes 3-D objects, it creates shadows and highlights. *Highlights* are the lightest areas, while the rest of your image will be in various stages of shadow.

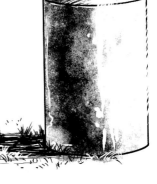

Practice With Simple Forms
In most cases the change from dark to light happens gradually. The brightest part of the object is where the light hits it directly; as the light dissipates, shadows creep in. The darkest areas are usually in the shadow cast by the object (called a *cast shadow*).

Represent the Light and Shadow Divide
Use heavy shading to represent the dividing line between the light and the shadow sides of any object. Then gradate the shading on either side of that divide, using lighter tones on the light side and darker tones on the dark.

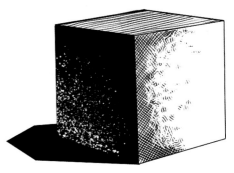

Hard Edges
Hard edges are marked by extreme divisions between light and dark. They typically occur anywhere that two planes, such as two sides of this cube, meet. Look for them also in the centers of shapes at the divisions between light and dark and on soft-textured objects, such as human skin under extremely bright light.

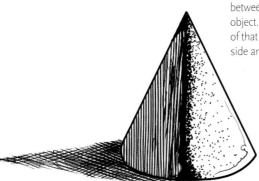

Light and Shadow Create Textures
The placement of the highlights and shadows creates the effects needed to show things like stone or cloth.

Use Light and Dark to Create Shape and Texture

Creating a believable drawing depends on your ability to manipulate the lights and darks to simulate textures. When light hits a crumbled stone head, it creates a pattern of lights and darks. That pattern is different from, say, the pattern created by light on a leather jerkin.

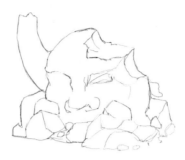

1 | Begin With Basic Shapes
Lightly sketch in the shapes that make up the stone head. After you're done, erase the loose strokes so you can plan the lighting.

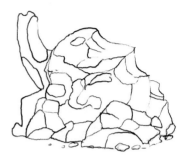

2 | Outline the Forms
Since the rock is a rough surface, you can be quite loose here. Use a fine-tipped black pen or marker to outline all the rock. Don't do the shading yet. Remember to do the division line between the light and the shadow area.

3 | Identify the Shadows
Use your pencil (HB or 2H is good here) to outline where the shadows will start. Shadows often begin at the very edge of a figure if there is a single direct light source, following the contour of the shape. Don't make the mistake of just doing it in a straight line. Use hatching for back shading, and crosshatching for the solid black areas.

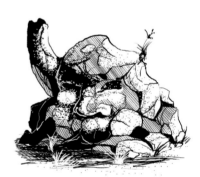

4 | Complete the Shading
With the same pen or marker, use crosshatching for the darkest shadows. Either save the small white areas or use a white correction pen to fill them back in. Trace over the diagonal lines you made before.

PERSPECTIVE AND PROPORTION BASICS

Perspective techniques are used to create the illusion of depth and distance on paper and other flat surfaces. *Foreshortening* is the perspective technique whereby lines or surfaces are made to appear shorter than they actually are in order to show depth.

Proportion is the size relationship of one thing to another. Objects or figures in the foreground of a drawing should appear larger in relation to those in the middle ground or background. We've all seen pictures that look out of whack because the proportions are off. By care-fully placing familiar objects of a known size (called *perspective markers*) in your drawing, you can give the viewer a proper sense of depth. To determine the correct size for each object though, you need to first figure out what kind of perspective you're dealing with.

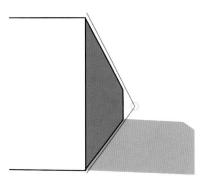

One-Point Perspective
One-point perspective is used for a straight-on view, not looking up at an angle or around cor-ners or using peripheral vision. The perspective lines all lead to one *vanishing point*, the point on the horizon line where all such lines converge. The *horizon line* represents the immediate impression of the viewer's eye level.

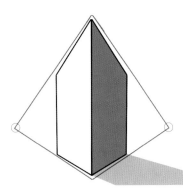

Two-Point Perspective
Two-point perspective is used for situations such as when you're standing on a street corner and can see two sides of a building at the same time. Each side of the building recedes to a dif-ferent vanishing point on the same horizon line.

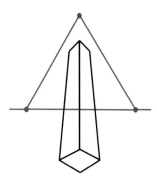

Three-Point Perspective
Three-point perspective would be used if you were to walk all the way up to that corner build-ing and look up. You could see the sides in your peripheral vision and the height as it juts into the sky. Three-point perspective gives a sense of height, depth and width.

Perspective and Extreme Foreshortening
The dagger hilt is severely foreshort-ened as it flies toward our hero. In real life, the hilt would need to be much bigger to fit in a hand. However, since we are looking almost straight at the hilt, much of its length is hidden.

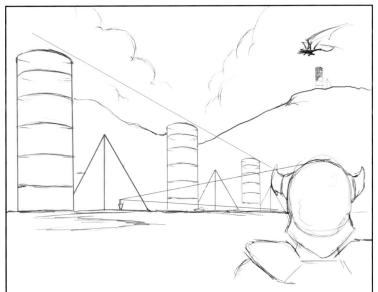

Perspective Markers Indicate Depth and Proportion
The perspective markers here are the towers, the pyramids and the dragon in the dis-tance. By incorporating the same elements in the background as in the foreground, we have an idea of how big that dragon actually is. The blue and red lines recede toward the vanishing points.

POINT OF VIEW DETERMINES PERSPECTIVE

Perspective changes depending on your point of view or the vantage point from which you see things. How your characters and subjects appear and how you apply foreshortening depends on the point of view from which you draw them. The horizon line represents the eye level of a person looking straight ahead. We talk about other points of view as they relate to that horizon line. There are three main points of view or vantage points.

➤ **Bird's-Eye View** means the viewer is looking down on the scene, or from above the horizon line. It appears as though you are in the air looking down. Used quite a bit in movies.

➤ **Worm's-Eye View** means the viewer is looking up at the scene, or from below the horizon line. It can do two things the bird's-eye view can't, it can either make something appear really large, or make the viewer feel really small (without hurting any feelings of course).

➤ **Eye-Level View** means—you guessed it—the viewer is looking straight on at the scene. You are here, says eye level.

The point of view is one of the many things you should be working out with your seed sketches.

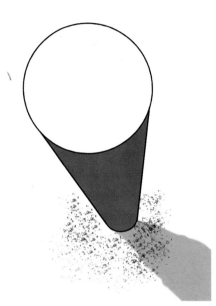

Bird's-Eye View of a Cylinder
What's nearest you (or the viewer) is always going to look bigger proportionally than things that are farther away. Looking down on the cylinder from above the horizon line, the top appears larger than the base.

Worm's-Eye View of a Cylinder
Looking up from a worm's-eye view, the base of the cylinder is closer to the viewer and the vanishing point is somewhere up in the sky.

Eye-Level View of a Cylinder
A straightforward introduction to an even plane with a common horizon gives the viewer the feeling of being in the scene from a natural standpoint without lying on the ground or flying in the air.

Draw Through to Keep Your Perspective Consistent
Draw all sides of your subject, even portions you can't see. This will help you more believably draw the parts of the object that you *can* see.

Begin With Foundation Sketches

There are three types of foundation sketches used to plan any drawing:

➤ **Gesture sketch.** A very loose, rough line drawing where you try to capture just the motion or pose of your subject. It may be little more than a stick figure with some perspective lines.

➤ **Primitive sketch.** A drawing that consists of very simple forms such as blocks, spheres and cylinders.

➤ **Balloon sketch.** A drawing in which the main shapes or muscle points of a figure taper toward one another.

Most artists begin with a gesture sketch, then move on to either primitives *or* balloons. Sketch the gesture, then practice primitive sketches and balloon sketches to see which you like better.

1 | Gesture Sketches Show Motion and Direction

Gesture sketching helps you get the feel of motion and determine which direction each body part should face. You should also be able to tell whether your character is balanced or not. Balance problems are fixed most easily in a gesture sketch.

2 | Primitives Consist of Basic Shapes

The term *primitive* comes from the 3-D art field and refers to the basic shapes that are used to create more elaborate forms. A primitive sketch makes it easy to get the foreshortening right. In this example, you can see the bottoms of some cylinders but not others, which immediately gives you the sense of things tilting toward you (light foreshortening). Remember to use little spheres to indicate joints in your primitive sketches.

2 | Sketch Muscles With Tapering Balloon Shapes

Ever try to squeeze two water balloons together? The balloons' effect on one another is called *tapering* (thick in the middle, thin on the ends). Sketching with this image in mind will give a more flowing and organic look to your drawings.

FANTASY WORLD PROPORTIONS

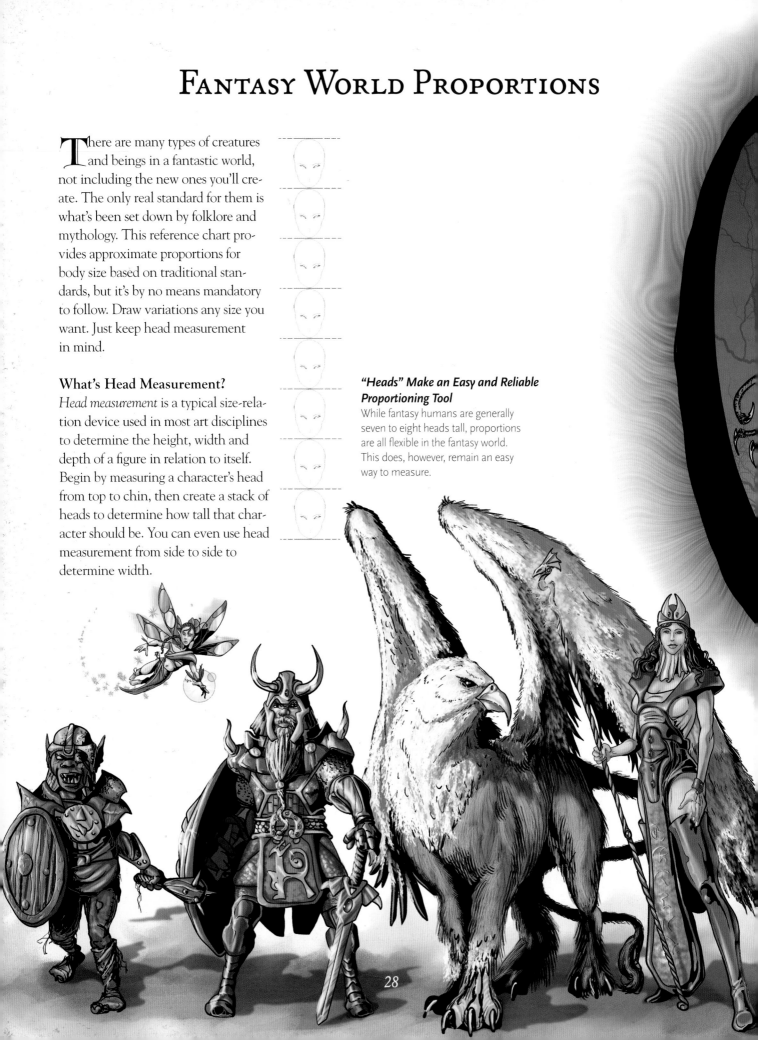

There are many types of creatures and beings in a fantastic world, not including the new ones you'll create. The only real standard for them is what's been set down by folklore and mythology. This reference chart provides approximate proportions for body size based on traditional standards, but it's by no means mandatory to follow. Draw variations any size you want. Just keep head measurement in mind.

What's Head Measurement?

Head measurement is a typical size-relation device used in most art disciplines to determine the height, width and depth of a figure in relation to itself. Begin by measuring a character's head from top to chin, then create a stack of heads to determine how tall that character should be. You can even use head measurement from side to side to determine width.

"Heads" Make an Easy and Reliable Proportioning Tool

While fantasy humans are generally seven to eight heads tall, proportions are all flexible in the fantasy world. This does, however, remain an easy way to measure.

Basic Architecture and Perspective

Let's combine what you've learned about perspective and sketching techniques to draw some architecture.

Not only providing atmosphere and setting, mysterious buildings do much to help give life to fantasy realms. Some of the most solid and simple designs can be very foreboding. Using the primitive method from gesturing allows you to get an immediate impression of perspective and overall shape. More complexity can be added as you go on, but getting the initial concept is what's important.

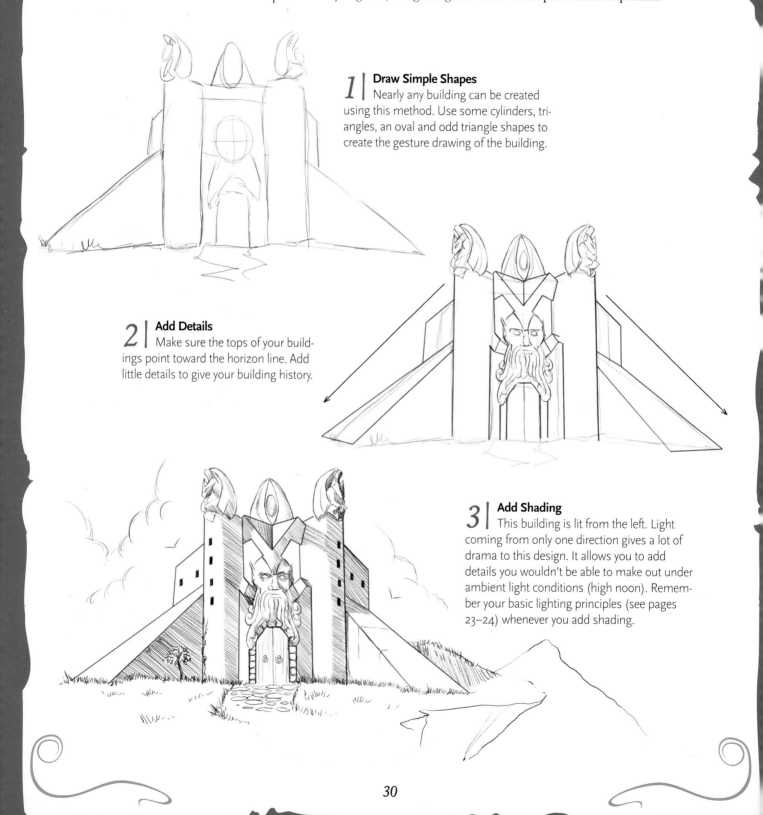

1 | Draw Simple Shapes
Nearly any building can be created using this method. Use some cylinders, triangles, an oval and odd triangle shapes to create the gesture drawing of the building.

2 | Add Details
Make sure the tops of your buildings point toward the horizon line. Add little details to give your building history.

3 | Add Shading
This building is lit from the left. Light coming from only one direction gives a lot of drama to this design. It allows you to add details you wouldn't be able to make out under ambient light conditions (high noon). Remember your basic lighting principles (see pages 23–24) whenever you add shading.

Draw Limbs With Sweeping Circles

The bodies of organic beings, such as people and animals, are made up of nothing but circles and spheres that generally follow a motion line. The *motion line* indicates the basic structure or flow of the being and tells you where to place its features.

Practice some sweeping circles before beginning this drawing. Take your time and sketch loosely. It's important to take a relaxed approach to your work.

You'll use this same technique as you begin to include more details in your drawings. The circles just become smaller and smaller to create muscle striations, veins, facial features and almost any other part of an organic creature.

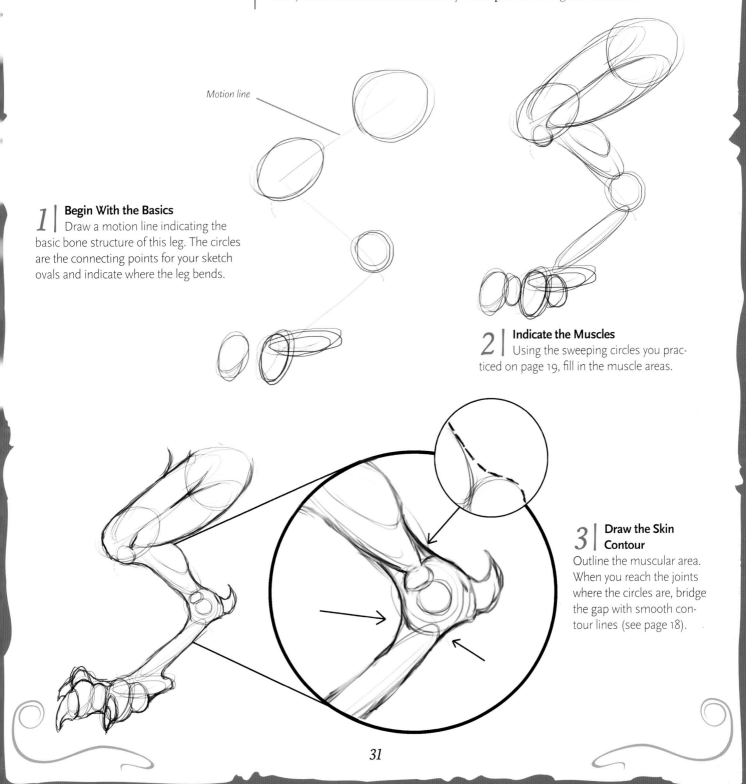

Motion line

1 | Begin With the Basics
Draw a motion line indicating the basic bone structure of this leg. The circles are the connecting points for your sketch ovals and indicate where the leg bends.

2 | Indicate the Muscles
Using the sweeping circles you practiced on page 19, fill in the muscle areas.

3 | Draw the Skin Contour
Outline the muscular area. When you reach the joints where the circles are, bridge the gap with smooth contour lines (see page 18).

Stack Sweeping Circles to Draw Faces

The sketch motion techniques and basic principles you've practiced so far will give your art a more flowing nature. Use them now to draw faces. Getting comfortable with the flow of drawing will help inspire you so you spend more time drawing and less time stuck by the "great white blank page."

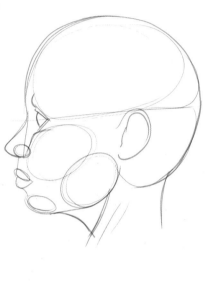
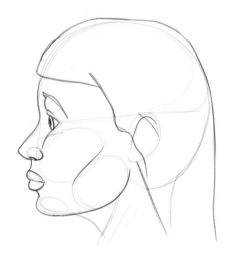
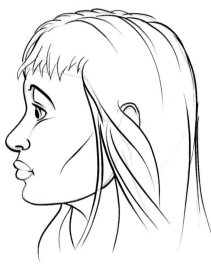

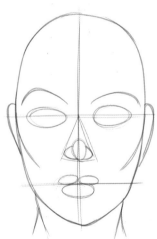
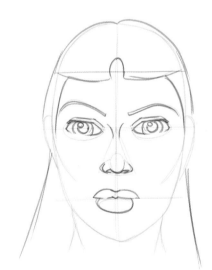
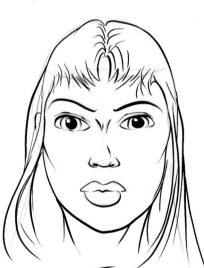

1 | **Begin With the Basics**
Use the circle stacking method that allows you to see the roundness and depth of the features even before inking or coloring.

2 | **Develop the Primitives**
Develop the primitives with details, taking into consideration standard facial measurements (typically measured with eye lengths as you did with head heights on page 28).

3 | **Develop the Drawing**
When you get the head looking the way you want it, detail it with contour lines accenting only parts of the face and not tracing over all the sketch lines.

Simplify Complex Figures

This sword mage (see page 76 for more mage information) illustrates how a seemingly complex figure involving foreshortening and elaborate armor can actually be broken down into very basic shapes and lines. Adding detail involves applying techniques you already know, only on a smaller scale.

1 | Create a Gesture Drawing
Draw the simple shapes. Take your time and add or subtract anything that you don't like. Her sword hand should be so foreshortened that it blocks almost her whole arm.

2 | Move On to Primitives
Primitives allow you to see the subtle design of the armor and to discover how to use the body to enhance the armor design.

3 | Add Detail and Erase Gesture Lines to Finish
The devices on her back make this drawing look complex, but they are really just simple shapes repeated on a smaller scale. The contrast between the straight, rigid blade and the curves of the figure makes her appear very casual and relaxed, almost ready to fight. It also makes her appear to be already in motion.

Look closely at the figure and pick out areas of clothing and body shapes—from hands to feet. They can all be expressed with primitives. Identify the basic shapes and modify them slightly to get the right look.

Use Feathering to Draw Mage Robes and Cloaks

By combining the feathering technique (see page 19) with some contour line strokes (see page 18), you'll make robes that would make any magic-user proud. The most important thing to remember when designing robe-type clothing is that each crease must end somewhere. Be sure you have a beginning and end to each crease.

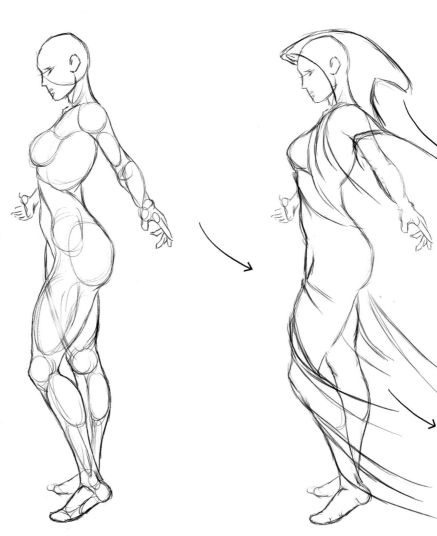

1 | **Begin With Body Structure**
Start with the basic bone structure (circle stacking and lines) and expand from there. Be sure to draw through your figure so you can easily get the proportions to look convincing (page 26).

Draw the Figure First

"Why not just draw the robe?" you ask. Well, a good foundation drawing leads to a much more believable clothed figure. You'll find that drawing clothing over a figure is much easier than trying to guess what's under the robe.

2 | **Add Robe Contours**
Choose a typical spot where a robe would bundle up, such as at the shoulders, knee or waist, and start from there with the feathering technique. Let the strokes from your pencil trail off to show a gentle wind blowing her about while she is casting a spell. The robe is flapping almost enough to lift her up.

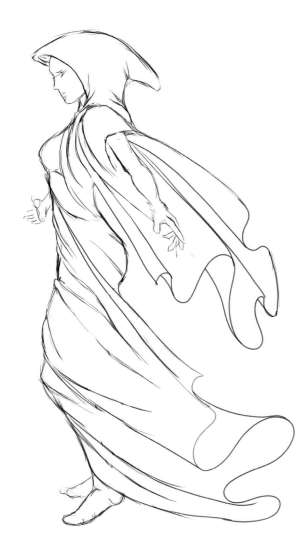

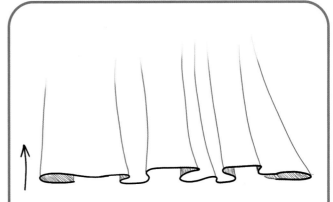

Bottom Edge of a Stationary Robe
Compare this line drawing with the drawing of the flowing robe. Draw a stationary robe flatter with more condensed loops since the robe is at rest. The darkest areas are the underlapping curves you create as you apply the vertical lines into the robe.

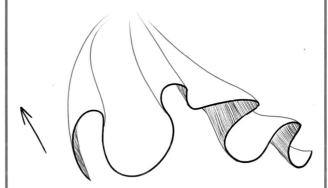

Bottom Edge of a Flowing Robe
Make the loops more rounded and pronounced for a flowing robe to create a feeling of fullness as though wind were blowing through them.

3 | Close the Robe
Connect the the edges left by your trailed-off pencil strokes with a fairly random curlicue line. Close the curlicue line just far enough away so that it doesn't connect to your contour lines. Once you have the flap look you want, carefully connect the high points of the curlicue line to the left-over robe lines. Erase the structure lines as needed.

Use Bar Sweeps to Draw a Gladiator Knight

Review the bar sweep technique from page 19 before you begin this demonstration. This type of detail adds depth and roundness to any figure. It's most useful for shields, wrist wraps, chest wraps and banded mail. The results will have others gawking at the huge amount of detail in your work.

1 | Begin With Body Structure

Stack sweeping circles to begin the basic body structure. Draw through your character. This guy likes straps so much, he has strapped together three shields! So, on his left arm, be sure to sketch in those ovals.

2 | Block In the Details

Use bar sweeps to sketch in only the most basic straps; add more detail later if you wish. Make sure the ends of the straps stick out and curve either up or down over the edge of his body or shields to give the feeling they are really there. They should add more depth to the knight.

Head Measurement

If you get stuck on the knight's proportions, review the head measuring technique on page 28.

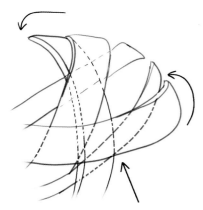

Draw Through to Create Complex Straps

You don't need to be this elaborate, but it certainly will enhance your draw through perception. Follow the dotted lines to draw through each strap.

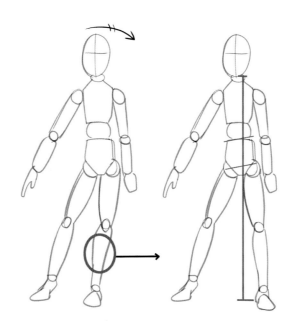

How to Achieve Proper Balance

If you find you have a character that appears off balance, first look at how the hips and feet are placed and spaced. At least one heel should be aligned with the body's center to give a center of gravity.

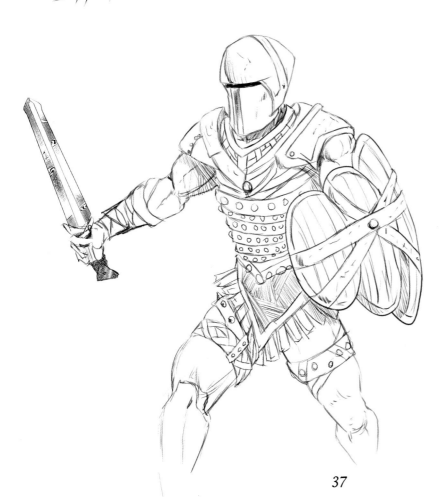

3 | Add Details to Finish

Add more strap details. Use bar sweep strokes for the armor and leather straps. Use quick bar sweeps to draw inside the larger straps you already have. Studs traditionally used on leather armor give the character authenticity and add variety to the design. Carefully erase your gesture lines when you have finished.

A Word On Inking

Inking adds a sense of uniformity and weight to an illustration, helping create a much neater, well-organized sense of design. Inking can be a very challenging but rewarding experience. I will show you how to make the most of your tools and your time. But nothing beats practice!

Ink your drawings in the following order for the best results:

1 Block in the blacks.

2 Add outlines.

3 Fill in details, working from the shadows to the highlights.

Blocking in the black areas first will help you decide the amount of line weight you should use and the direction of light. Some aspiring artists end up with their line weight work in opposition to the light source. Blocking in the blacks first serves as a solid reminder and helps reduce such mistakes greatly.

Just as you would do a texture from dark to light; the same applies to the big picture. Add dark areas first, then add the finer details.

Control Line Weights With the Brush
By pushing down gently with a loaded brush you can create subtle differences in line strength. Light strokes produce thin lines for areas closer to the light source. Increase pressure to create thicker lines as you move to shadow areas.

Filling Large Areas
Both a flat no. 2 brush or an India ink marker work well for quickly filling in dense areas. Make sure your surface is a heavy bristol or double-layered art board, as ink tends to bleed through standard paper and even some art papers.

Brushes are best for line contour work, outlining, adding weight and graceful flowing lines for clothing and cloaks.

Crow quill pens are great for crosshatching, short detail strokes, loose ink rendering and getting into small spots.

Technical pens are superior for pointillism, making straight edges and creating patterns that require exactness in line width.

Different Tools Work Best for Different Techniques
This is only partially inked so you can see the different advantages of each tool.

INKING APPROACHES

There are many approaches to inking, and finding the right one for you is just a matter of experimenting. I use line-contour, full-texture and high-contrast inking frequently. Together, these three give you tons of options for every picture.

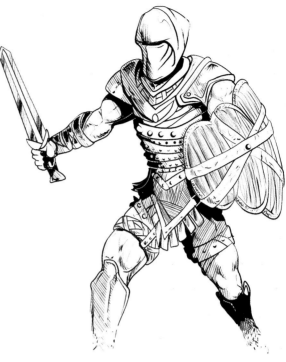

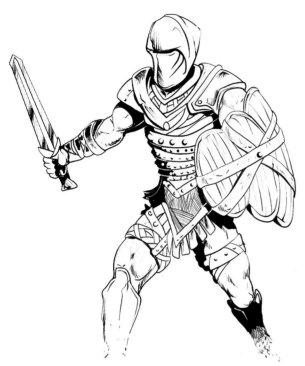

Full-Texture Inking
This approach is typical of illustration in books and role-playing game art. It's not completely realistic, but there would be little room for coloring here. With such a detailed figure, you need a simple background made of mostly contour lines and some solid shadows (see page 18).

Line-Contour Inking
Generally used in the comic industry, line-contour inking is simple and clean and leaves plenty of room for color. Most of the texture will emerge with the color, so you apply very little with ink. If you are adding color with marker or paint, apply that first and add ink after the paint dries.

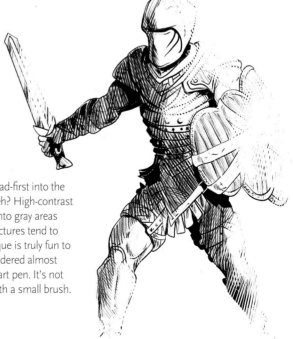

High-Contrast Inking
So this guy has been dipped head-first into the India ink well. Pretty dramatic, eh? High-contrast inking has very little gradation into gray areas and the illustrations in scene pictures tend to look more realistic. This technique is truly fun to experiment with and can be rendered almost completely with a crow quill or art pen. It's not something you can do easily with a small brush.

The Creatures

Fantasy realms are filled with creatures. Some are evil, some are good and some are singularly neutral. They all have one thing in common though; they don't exist in our world. Many originated in mythology and folklore and have been adopted into fantasy literature, role-playing games and video games. It seems that whenever humans are inspired to create another world, they love to populate that world with monsters. After all, what would our characters do if they didn't have dragons to chase them?

In this chapter you'll learn the basics for creating beasts of your very own.

Dragons

Dragons are mental giants compared to most mythical beasts. Many stories depict them as powerful as the mightiest sorcerer you can imagine. Every dragon is unique, and its appearance generally matches its personality. Although dragon characteristics continue to evolve, some traditional features are typical. These include:

1 Lizardlike features **2** Batlike wings

3 Catlike or dinosaurlike legs **4** Snakelike necks

Considering the number of lizard, bat, cat and snake species there are, you can imagine the variations possible. Once you stumble upon a combination that inspires you, a natural style for your dragons will emerge.

1 **Begin With Seed Sketches**
Some artists draw dragons as very alligator- or even doglike. Mine look more birdlike in terms of head construction. No matter what you base your dragons on, focus on the details to bring them to life.

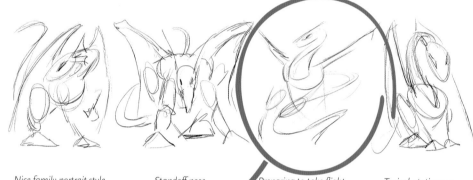

Nice family-portrait style *Standoff pose* *Preparing to take flight* *Typical, static pose*

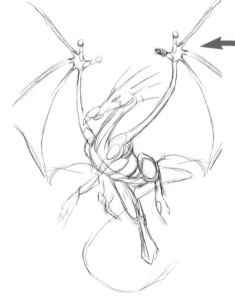

2 **Choose a Seed Sketch Pose and Begin Details**
Most dragons require lots of foreshortening to give the viewer an idea of the immensity of their size in relation to themselves and the environment. Emphasize lots of foreshortening with the appendages like talons, legs and wings. Draw through to keep the effect of motion.

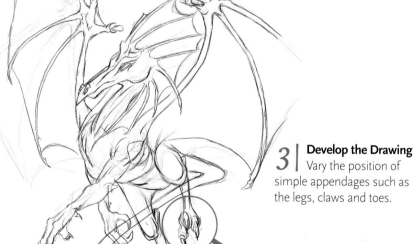

3 **Develop the Drawing**
Vary the position of simple appendages such as the legs, claws and toes.

42

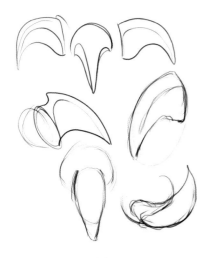

Create a Clay Model
Use modeling clay to sculpt a small claw. Then practice drawing your 3-D model from different angles.

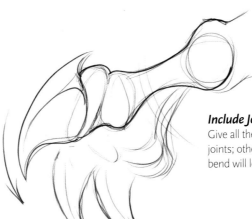

Include Joints
Give all the limbs the appropriate number of joints; otherwise, areas of your creature that bend will look rubbery.

Use a Primitive Sketch to Begin the Head
Begin the head with spheres. Use the same sort of combination you would use for a horse, but make the nose much shorter. Once you've established the basic form, you can add your own details.

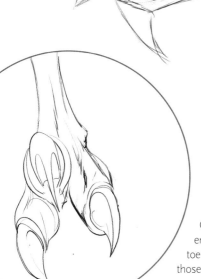

Vary the Positions of Each Claw and Toe
One foot can contain many different angles. Foreshorten the middle toe more than the others to make those claws really look active.

Practice Drawing Body Parts

If you draw one type of creature often, it's good practice to draw challenging or difficult parts from various angles and perspectives to become more familiar with how those parts are constructed and how they move. Many artists have trouble with dragon claws and toes.

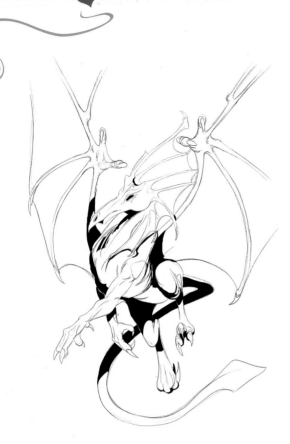

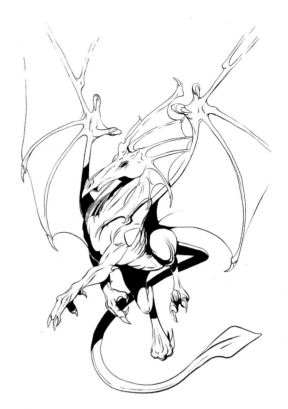

4 | **Add the Darkest Areas**
Use solid black for the parts of the dragon in shadow, varying the shades according to the depth of the shadow. The very darkest areas should be solid black. You'll have to determine which are the most important to include to give the dragon a solid feel.

5 | **Add Lines and Textures**
The lines of a dragon are long and sleek, so a brush is best for most of the line work. Use heavier lines to show the dragon's muscle and give dimension to the tail.

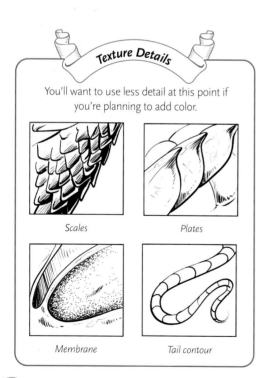

Texture Details

You'll want to use less detail at this point if you're planning to add color.

Scales

Plates

Membrane

Tail contour

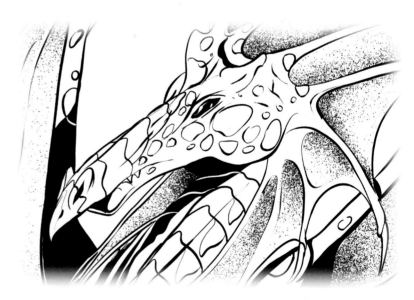

6 | **Finish the Drawing Details**
The line weights work here to help the viewer gain a sense of light distribution and depth. The pen size can vary. Just remember that the larger the point of your pen, the more difficult it will be to do tightly detailed work. Use pointillism to add the shadows in the wings.

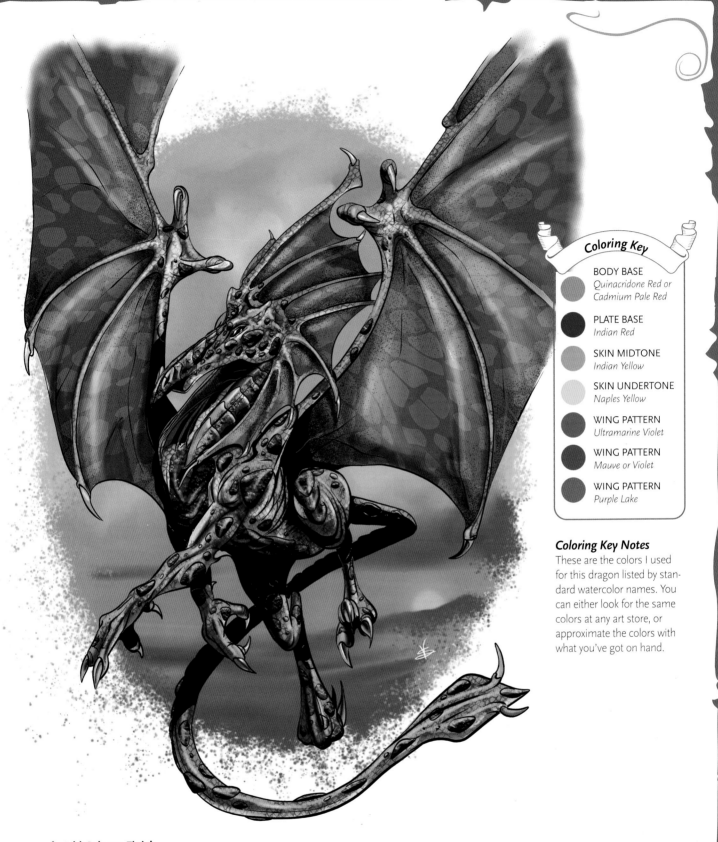

Coloring Key

BODY BASE
Quinacridone Red or Cadmium Pale Red

PLATE BASE
Indian Red

SKIN MIDTONE
Indian Yellow

SKIN UNDERTONE
Naples Yellow

WING PATTERN
Ultramarine Violet

WING PATTERN
Mauve or Violet

WING PATTERN
Purple Lake

Coloring Key Notes
These are the colors I used for this dragon listed by standard watercolor names. You can either look for the same colors at any art store, or approximate the colors with what you've got on hand.

7 | Add Color to Finish
Good observation of lizards and their kind will go a long way toward helping you enhance your own dragons. You may have noticed that the inner areas like the arms and chest of the dragon are much lighter than the rest of him, and even the scale pattern gradually fades to give a more convincing lizardlike feel.

Goblins

Goblins are a mainstay of the fantasy field, often serving as templates for other edgy animal-like warriors. They frequently appear in illustrations depicting battles against the main characters. Only rarely are they very smart.

1 | **Begin With Seed Sketches**
Foreshorten only slightly; you want to show as much of the creature as possible while keeping the figure in motion. Do as many seed sketches as necessary to find the goblin you want to draw.

 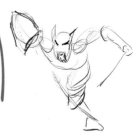

Stalking out of the dark *Unsuspecting, glancing over his shield* *Running; he means business* *Angry, charging the person just off to the left of the viewer*

2 | **Develop the Primitive Sketch**
The sword should be above his head but not touching his ear. It's very important to watch those tangents (see sidebar)! Construct loosely, using a light H pencil. Make sure the scabbard is on the correct side—usually opposite to the arm that draws the weapon from the sheath. If it's on the back, it is generally centralized behind the head.

3 | **Develop the Drawing**
Begin filling in the details. Make sure you give the goblin something to stand on. He should look like he's touching the ground.

What's a Tangent?

A tangent occurs where two lines touch at a single point. In the case of the goblin, if there was a tangent between the lines of the sword and the ear, it would look like he was jabbing himself.

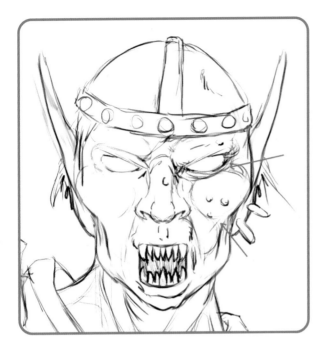

Add Detail to the Goblin Face

Stack and squash the circles like clay to create more character detail. Make him really creepy! Don't be afraid to experiment with different features or even multiple ones. Add more face armor, or even rivet some metal plates to his head for that "I am really tough" look.

Use Bar Sketching on Armor

Vary your sketching to create patterns on his shoulder armor, rather than just plain boxes.

Use Sweep Sketching for Clothing

Sweep sketching will really give fullness and motion to clothing. Remember to form the clothing around the character, tapering off in V- or C-shapes at the edges.

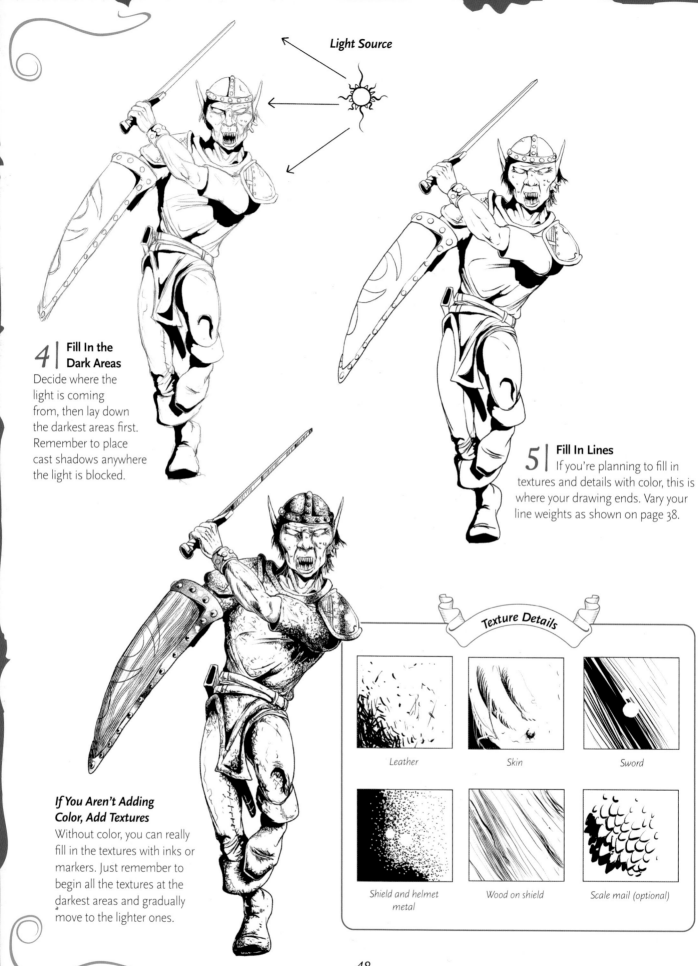

Light Source

4 | Fill In the Dark Areas

Decide where the light is coming from, then lay down the darkest areas first. Remember to place cast shadows anywhere the light is blocked.

5 | Fill In Lines

If you're planning to fill in textures and details with color, this is where your drawing ends. Vary your line weights as shown on page 38.

If You Aren't Adding Color, Add Textures

Without color, you can really fill in the textures with inks or markers. Just remember to begin all the textures at the darkest areas and gradually move to the lighter ones.

Texture Details

Leather	Skin	Sword

Shield and helmet metal	Wood on shield	Scale mail (optional)

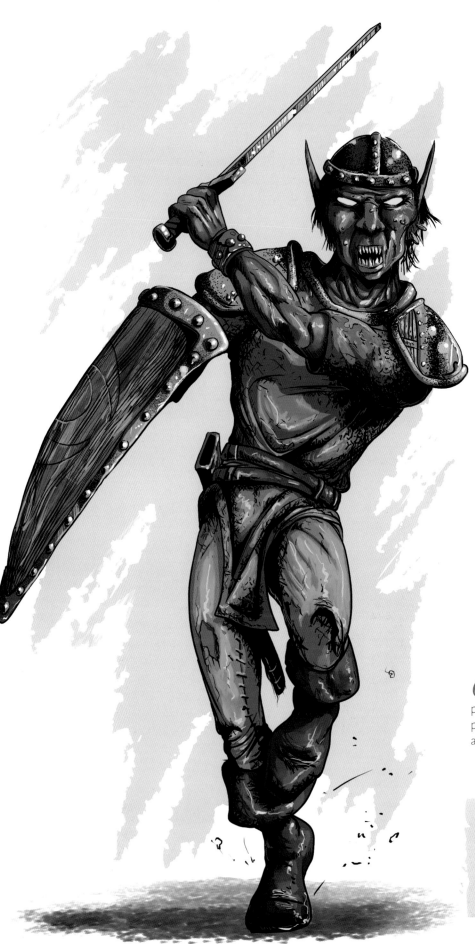

Coloring Key

Coloring Key

SKIN
Chromium Oxide Green

EYES
Chrome Yellow

TEETH
Greenish Yellow

METAL BASE
Payne's Gray, light

JERKIN
Raw Sienna

PANTS
Raw Umber

BOOTS
Van Dyke Brown

SHIELD WOOD
Burnt Umber

SWORD
Pewter

Coloring Key Notes

Always vary your colors and values, even if they are similar. The hues used for the leather all come from the same color for example, just different values.

6 | **Add Color to Finish**
This example was colored by computer. If you decide to color with watercolor paints, pencils or markers, make sure you add the color before adding the darks.

Hue and Value

Hue *refers to a named color, such as Violet-Blue. Value refers to the lightness or darkness of a hue.*

Demons

Demons tend to add intrigue rather than terror to a storyline. The presence of demons typically means that someone somewhere has been messing with things that they weren't supposed to—or that some prophecy has come to pass. The design of the demon itself should hint at the place that this malevolent entity came from; surround your demons with mist, fire, smoke, blazing energy, bugs or tiny demons. Body shapes may vary from human to animal to insectlike. Any way you look at them, demons exude malice and their body language is threatening. We'll be working here with a visitor from another dimension.

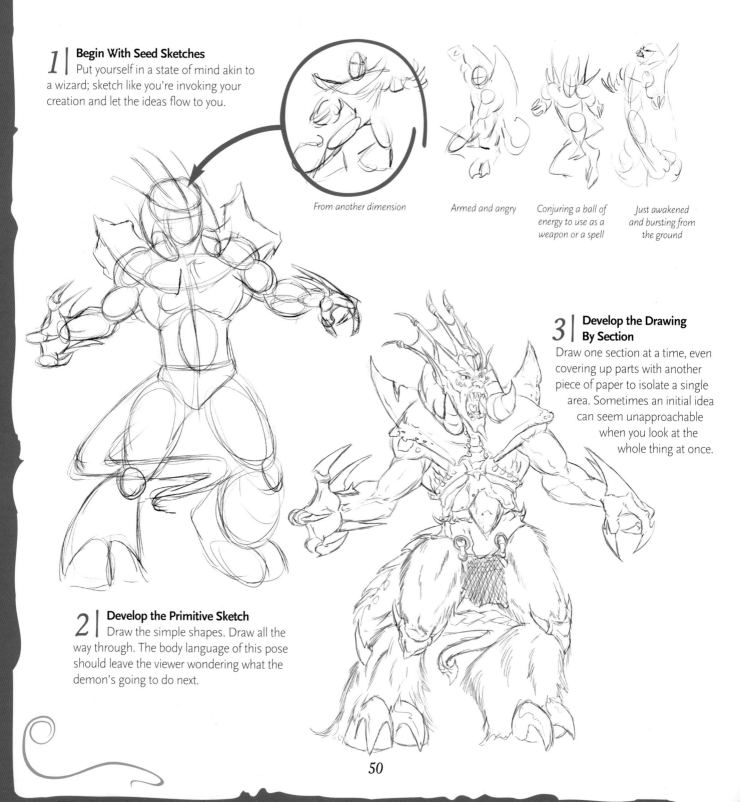

1 | Begin With Seed Sketches
Put yourself in a state of mind akin to a wizard; sketch like you're invoking your creation and let the ideas flow to you.

From another dimension

Armed and angry

Conjuring a ball of energy to use as a weapon or a spell

Just awakened and bursting from the ground

3 | Develop the Drawing By Section
Draw one section at a time, even covering up parts with another piece of paper to isolate a single area. Sometimes an initial idea can seem unapproachable when you look at the whole thing at once.

2 | Develop the Primitive Sketch
Draw the simple shapes. Draw all the way through. The body language of this pose should leave the viewer wondering what the demon's going to do next.

Demon Brows
Brows on demons (if they have them) point toward the bridge of the nose so the demons constantly wear a mean expression.

Develop the Skull With Basic Shapes
Use spheres on areas that are very pronounced. Draw side views, top views and more to cquaint yourself thoroughly with your character.

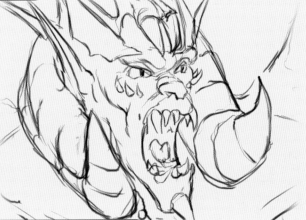

Head Perspective
This perspective of the head with the wraparound horns leaves the skull structure kind of a mystery, though it appears apelike. The not-quite-profile view (otherwise known as a 3/4-view) obscures almost half his features so you're only drawing a portion of the demon's horns and face.

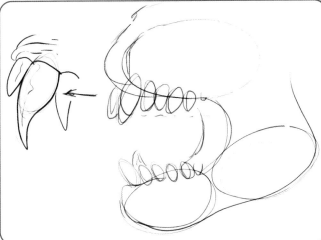

Placement of Demon Teeth
Make sure to place the demon's teeth in his gums and not just on top of them. They should look like they have roots.

Demon Claws
A typical claw consists of eight spheres. Nearly any creature can be drawn with these. Place the the larger spheres on the inside to make up the main contour of the palm part. Place the rest from the largest near the palm to the smallest near the claw or fingertip.

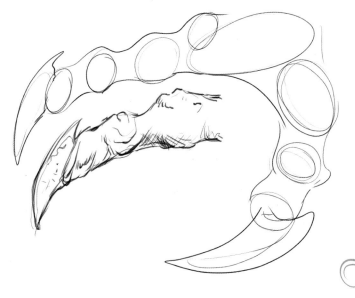

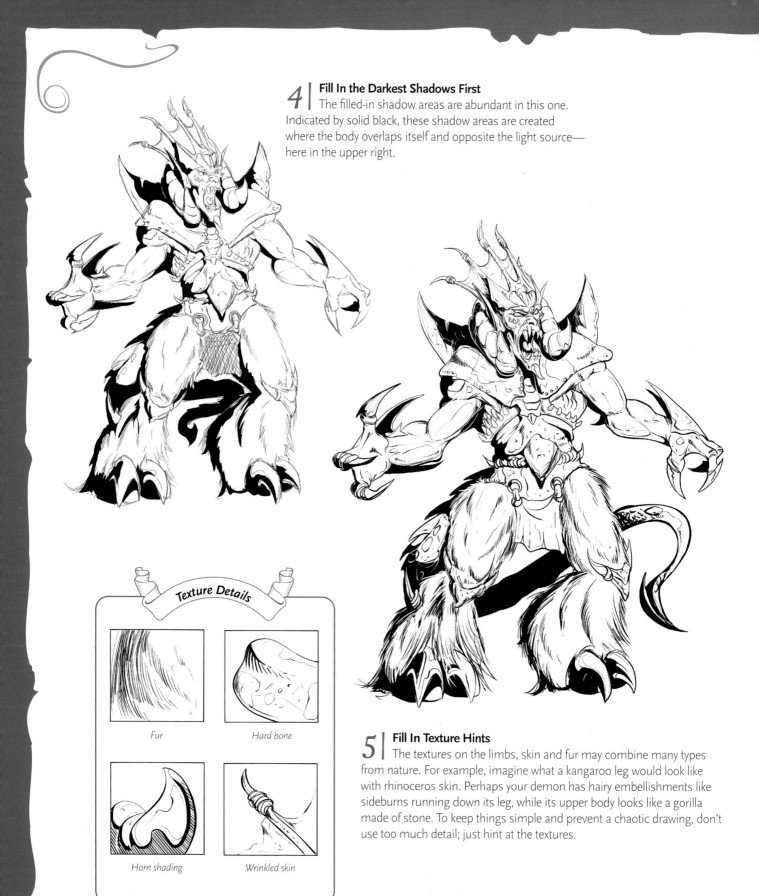

4 | Fill In the Darkest Shadows First

The filled-in shadow areas are abundant in this one. Indicated by solid black, these shadow areas are created where the body overlaps itself and opposite the light source—here in the upper right.

Texture Details

Fur

Hard bone

Horn shading

Wrinkled skin

5 | Fill In Texture Hints

The textures on the limbs, skin and fur may combine many types from nature. For example, imagine what a kangaroo leg would look like with rhinoceros skin. Perhaps your demon has hairy embellishments like sideburns running down its leg, while its upper body looks like a gorilla made of stone. To keep things simple and prevent a chaotic drawing, don't use too much detail; just hint at the textures.

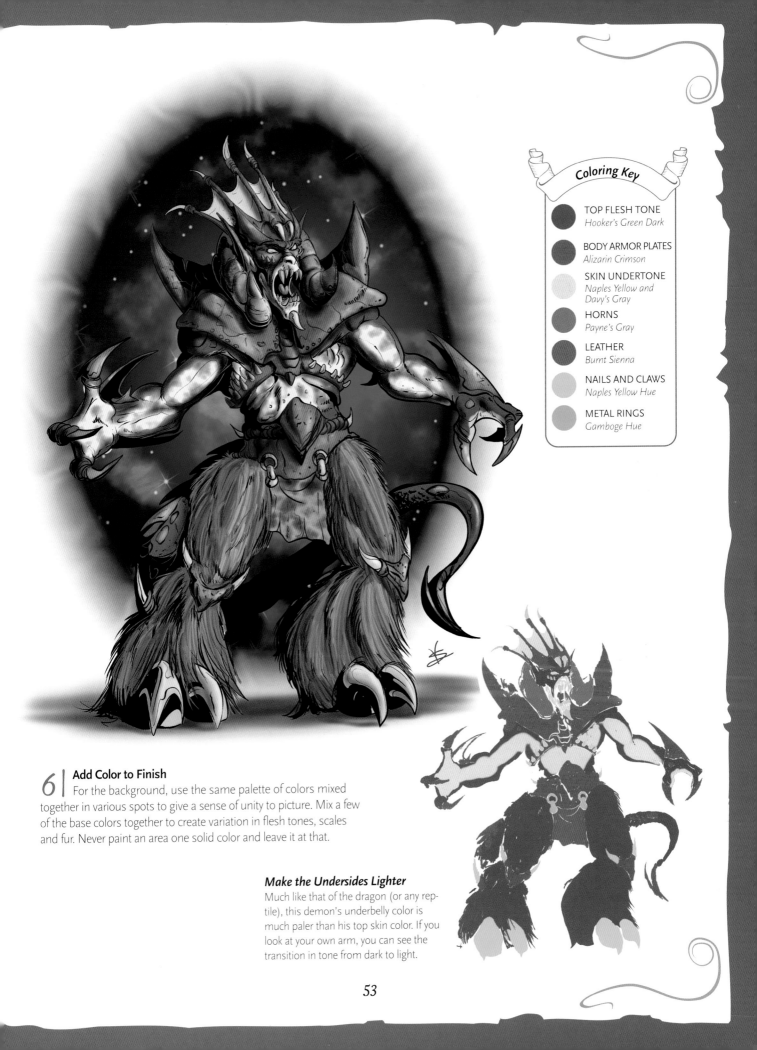

Coloring Key

TOP FLESH TONE
Hooker's Green Dark

BODY ARMOR PLATES
Alizarin Crimson

SKIN UNDERTONE
Naples Yellow and Davy's Gray

HORNS
Payne's Gray

LEATHER
Burnt Sienna

NAILS AND CLAWS
Naples Yellow Hue

METAL RINGS
Gamboge Hue

6 | Add Color to Finish

For the background, use the same palette of colors mixed together in various spots to give a sense of unity to picture. Mix a few of the base colors together to create variation in flesh tones, scales and fur. Never paint an area one solid color and leave it at that.

Make the Undersides Lighter

Much like that of the dragon (or any reptile), this demon's underbelly color is much paler than his top skin color. If you look at your own arm, you can see the transition in tone from dark to light.

53

Griffins

A griffin (also spelled *gryphon*) is an intimidating, regal combination of lion and eagle. They can be threatening when the need occurs, making them excellent guardians. I use griffins typically as mounts for princesses, knights and wizards.

1 | Begin With Seed Sketches

Think of a guardian animal, such as a dog. Then imagine what he would look like part eagle and part lion.

Appears overly menacing

Looks too much like a heraldic symbol on a shield

Still too menacing

Difficult for perspective and not at all regal

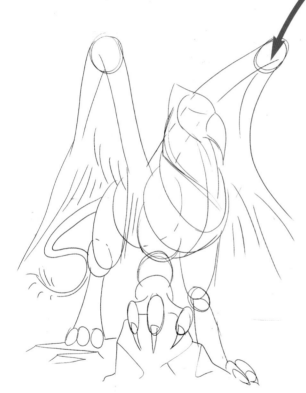

2 | Develop the Primitive Sketch

Use a series of overlapped spheres and circles to show foreshortening. Add some interpretive line strokes to give the feeling of feathers. Be sure to draw through!

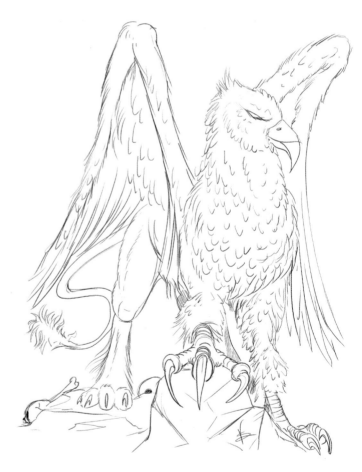

3 | Develop the Drawing

Loosely define the line to portray the fullness and fluffiness of feathers. Most of this drawing's development will happen when you add shadows.

Feather Textures
Use overlapping feathering strokes to draw feather texture and direction (see page 19).

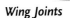

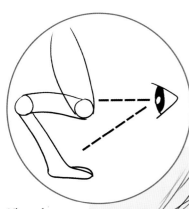

Wing Joints
Wings bend, so they must have joints. There are two main joints in the wings. Add the rows of feathers between them as indicated by the dotted lines.

Viewer's Perspective of the Leg
When the viewer looks at the leg straight on, only the knee and the bottom portion of the leg are visible.

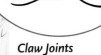

Claw Joints
Claws bend in much the same way as our own fingers.

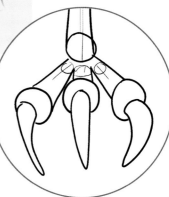

Foreshorten the Leg
The lionlike leg is at a sharp angle here. Make sure the kneecap overlaps a good portion of the leg to show this.

Claw Texture
Use contoured overlapping lines to give the impression of the accordionlike, very flexible aspect of the skin.

Foreshorten the Claws
Looking straight at the claws, the viewer can't see all the joints. Block out the structure very simply to see this.

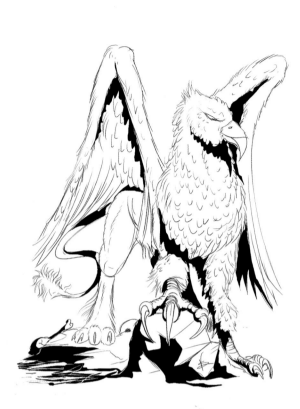

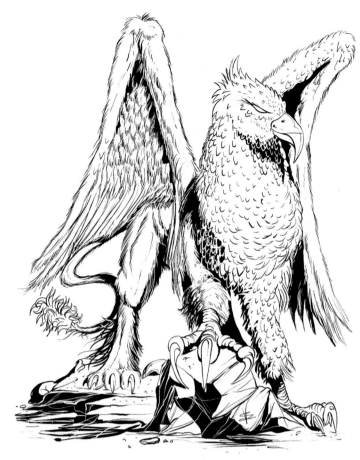

4 | Fill In the Shadows

Determine the position of the light source and fill in the main shadows with solid black. You can also outline the solid areas with pen first and fill in the areas with a flat brush.

5 | Fill In the Details

The griffin is but a collection of single brush and pen strokes. Applying hair and feather strokes in various directions guides the viewer over the contour of the animal. Look at references of other animals and note the direction of the fur over various muscle groups.

Fur and Feather Strokes

Use a brush or an artist's pen to make quick strokes with a flick of the wrist, pulling up the pen to create the dagger stroke.

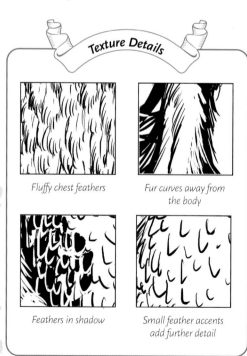

Texture Details

Fluffy chest feathers

Fur curves away from the body

Feathers in shadow

Small feather accents add further detail

Work in Small Doses

Sometimes a drawing is too much to deal with all at once. To break up the monotony, work on several images at a time and divide each one into separate tasks. With this griffin, I sat down and said "wings" and did the wings. I then set that drawing aside to work on something else. When I eventually came back to it, I focused on the chest feather strokes.

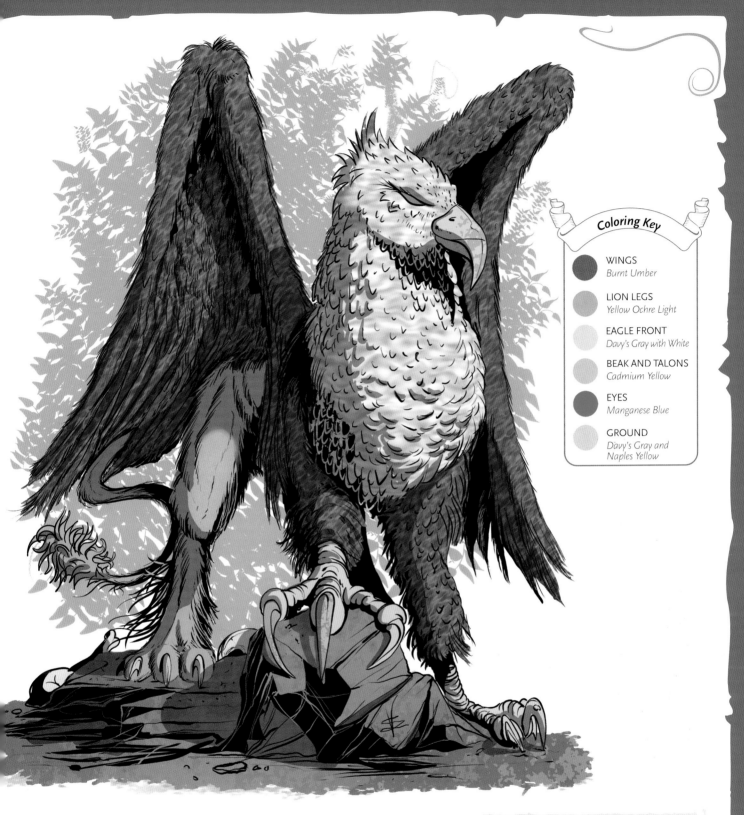

Coloring Key

WINGS
Burnt Umber

LION LEGS
Yellow Ochre Light

EAGLE FRONT
Davy's Gray with White

BEAK AND TALONS
Cadmium Yellow

EYES
Manganese Blue

GROUND
Davy's Gray and Naples Yellow

6 | Add Color to Finish
Your final image should depict a regal creature that is poised and ready to guard, defend or question.

Feathers aren't very reflective (unless they're iridescent), so there won't be many harsh highlights. Add texture to the colored wings using either a digital noise filter to simulate the softness or an art sponge (dab lightly and be sure to ink first).

Digital Noise Filter

Noise filters create very sandlike effects— similar to a grainy photo using many colors to create a soft impression of detail.

Gargoyles

As guardians of secret towers and protectors of castles, gargoyles are at the core of many medieval stories—both adventure and horror. One thing that remains consistent is that at night gargoyles come alive, restless and watchful. When daylight approaches, they return to their stone forms.

Even when animated, gargoyles keep their stone appearance and toughness. Most sculptures are made of marble, granite or sandstone. Your ability to create believable gargoyles will depend largely on your ability to re-create the look of these stones. To practice drawing the different rock types, look for photo references of *quarry stone* online or at the library.

1 | Begin With Seed Sketches
When I thought of seed sketches for the gargoyle, I thought of monkeys and how they act in cages and how they sit on tree limbs.

Waking up *About to shake hands* *Hanging around* *Attacking*

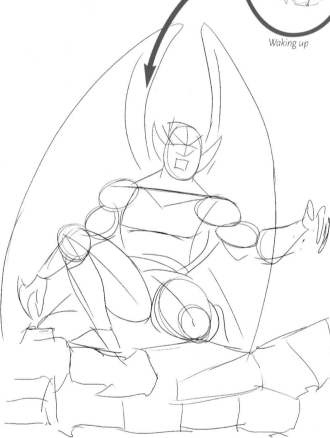

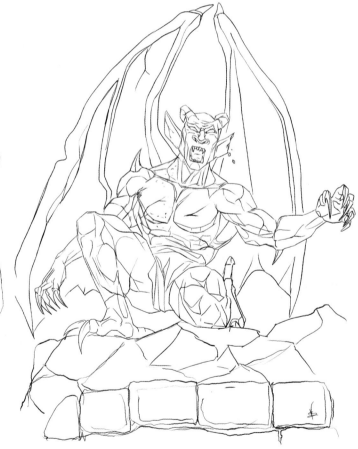

2 | Develop the Primitive Sketch
This gargoyle is just waking up, so the stone is just beginning to move. Throw in some extra rocks and a bit of a ledge so he appears to be perched on a wall. Keep your sketch blocky to add to his stonelike appearance.

3 | Develop the Drawing
This line art requires shaky straight and crooked lines; the anatomy doesn't have to be perfect. The more choppy it is, the more carved the gargoyle will appear—and that's what you want.

Use Chunky Lines for the Horns

A typical horn will be smooth and curvy. For this one, use straight, chunky lines to simulate a rough stone carving.

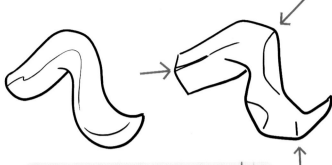

Use Basic Triangles for the Head

Triangular, sharp features really add to his evilness. Add details such as chips and gouges as I am sure this fellow has had a brawl or two with his own kind and other dangerous adventurers. Add a couple of pebbles in midair to suggest the motion as he comes to life.

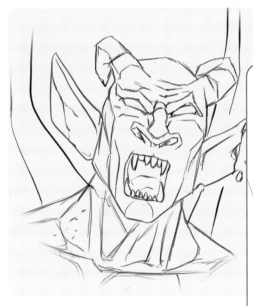

Create Stone Cracks

Wherever the body would bend or flex, there should be cracks to portray the wear and tear on our guardian.

Make the Hands Blocky

There are no smooth or curvy lines on these hands.

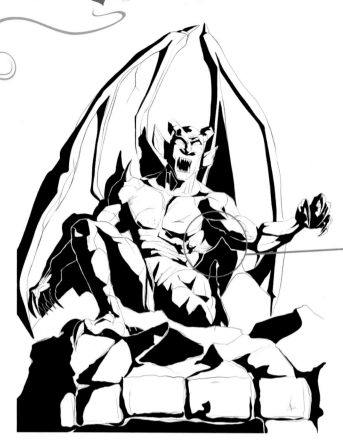

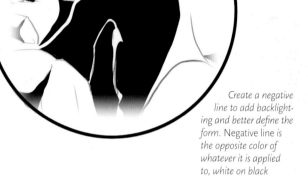

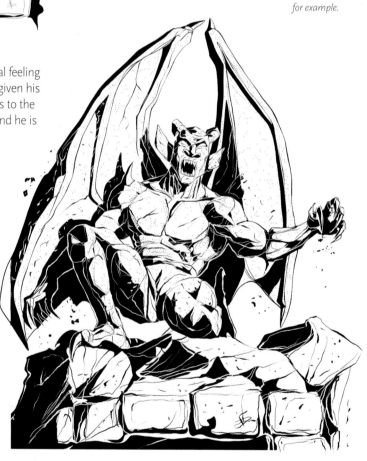

Create a negative line to add backlighting and better define the form. Negative line is the opposite color of whatever it is applied to, white on black for example.

4 | Add the Darkest Darks

A lot of black gives a mysterious and almost dismal feeling to a character. Plus, the shadows will be especially heavy given his sharp angles and the fact that it's dusk. The light source is to the lower right, as though you came upon him with a torch and he is perched upon the door frame.

Texture Details

Cracks in stone

Gaps in stacked stone, with or without mortar

Broken-off stone, sheared and jagged

Slate or layered stone

5 | Develop the Textures

Add specks of falling debris to suggest the motion as he comes alive. Add marks, dots and dashes to the stone and gargoyle to give the impression of natural gouges.

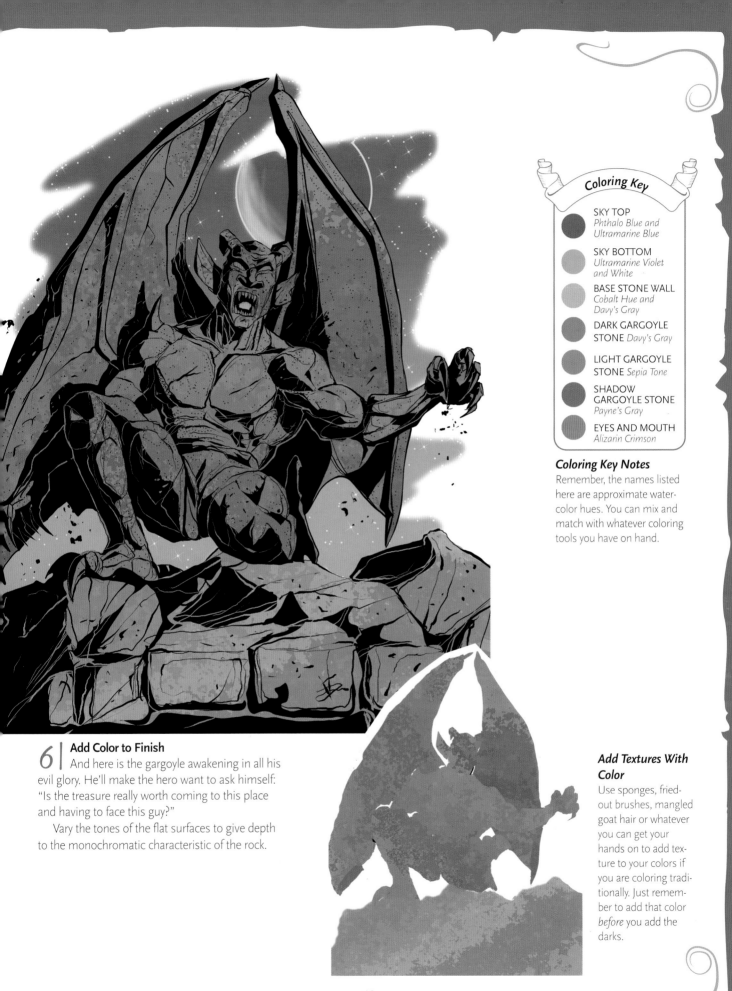

SKY TOP
*Phthalo Blue and
Ultramarine Blue*

SKY BOTTOM
*Ultramarine Violet
and White*

BASE STONE WALL
*Cobalt Hue and
Davy's Gray*

DARK GARGOYLE
STONE *Davy's Gray*

LIGHT GARGOYLE
STONE *Sepia Tone*

SHADOW
GARGOYLE STONE
Payne's Gray

EYES AND MOUTH
Alizarin Crimson

Coloring Key Notes
Remember, the names listed
here are approximate water-
color hues. You can mix and
match with whatever coloring
tools you have on hand.

6 | Add Color to Finish
And here is the gargoyle awakening in all his
evil glory. He'll make the hero want to ask himself:
"Is the treasure really worth coming to this place
and having to face this guy?"

Vary the tones of the flat surfaces to give depth
to the monochromatic characteristic of the rock.

Add Textures With Color
Use sponges, fried-
out brushes, mangled
goat hair or whatever
you can get your
hands on to add tex-
ture to your colors if
you are coloring tradi-
tionally. Just remem-
ber to add that color
before you add the
darks.

The Characters

Characters are the cornerstone of nearly every story. Most characters have a specified class, which describes their specialties, abilities and—in many cases—their nature. Most classes fall into three categories: magic-users, fighters and thieves. There are countless possibilities for derivations and combinations as well.

You also have to determine race. Will your character be human, elf, halfling, faery or some combination? No matter what your characters' heritages, they all deserve to be embellished with specialized body language, clothing, color, weaponry and magical items.

As in the previous chapter, each demonstration begins with seed sketches and ends with a fully colored image. You'll learn distinct ways of creating textures and line art to enhance any personality and bring your own fantasy characters to life.

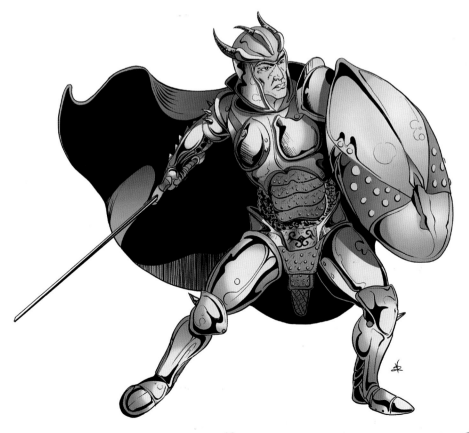

Warriors

Warriors are defenders and protectors of all that is worth standing up for. They come in many forms, including scouts, adventurers, escorts, guides, bodyguards and spies. Warriors are expert fighters not only in hand-to-hand combat, but also often in combat styles requiring special training and unique weaponry.

As defenders and protectors, they are often nomadic, so they wear an assortment of mix-and-match armor. The style of their armor and clothing is also affected by the setting of the story and the warrior's race or place of origin.

This elven adventurer-warrior is from a southern, forested region. A highly skilled swordmaster with long sword ready, she fears nothing.

1 | Begin With Seed Sketches

I was going for a "watch and ready" feel with this warrior.

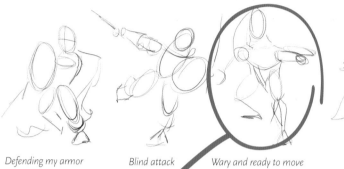

Defending my armor Blind attack Wary and ready to move Statuesque

2 | Develop the Primitive Sketch

This female half-elven warrior has a very subtle curvy pose. Watch the balance of the stance and include deliberate bends in the knees and elbows. Make sure the feet are planted firmly on the ground, and the shoulders are squared off with the knees.

3 | Develop the Drawing

Add the form-fitting armor. Warriors do a lot of running and jumping around, so they can't have bulky clothes in their way. Consider the environment and what you imagine your character will be doing as you design the armor. And always, always draw through!

Choose Your Sword Type

Some sword types typical of this class regardless of race are: long sword, short sword, rapier, cutlass and broadsword to name just a few. To find others, search online for: medieval weapons.

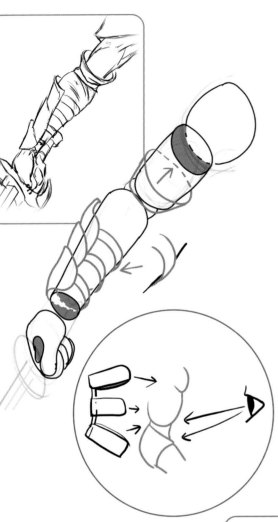

Follow the Abdominal Contours

Consider the overall shape of the abdominal area from different perspectives. Then make sure the straps and clothing bend and curve to follow the body's contour. To make it easier for yourself, visualize the abdomen as a series of connecting disks.

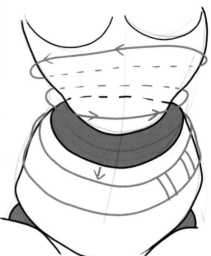

Draw Through for Arm Plating, Too

Drawing the correct angles and curves for the plating and straps is very important to get a sense of roundness and fullness in your character. The perspective and dimensionality have to make sense to the viewer according to the point of view you want to depict.

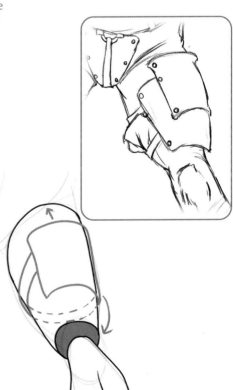

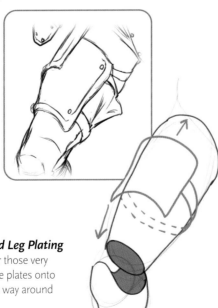

Draw Through for Stacked Leg Plating

To create the correct angle for those very important straps that hold the plates onto her legs, draw a sketch all the way around the breadth of the thigh.

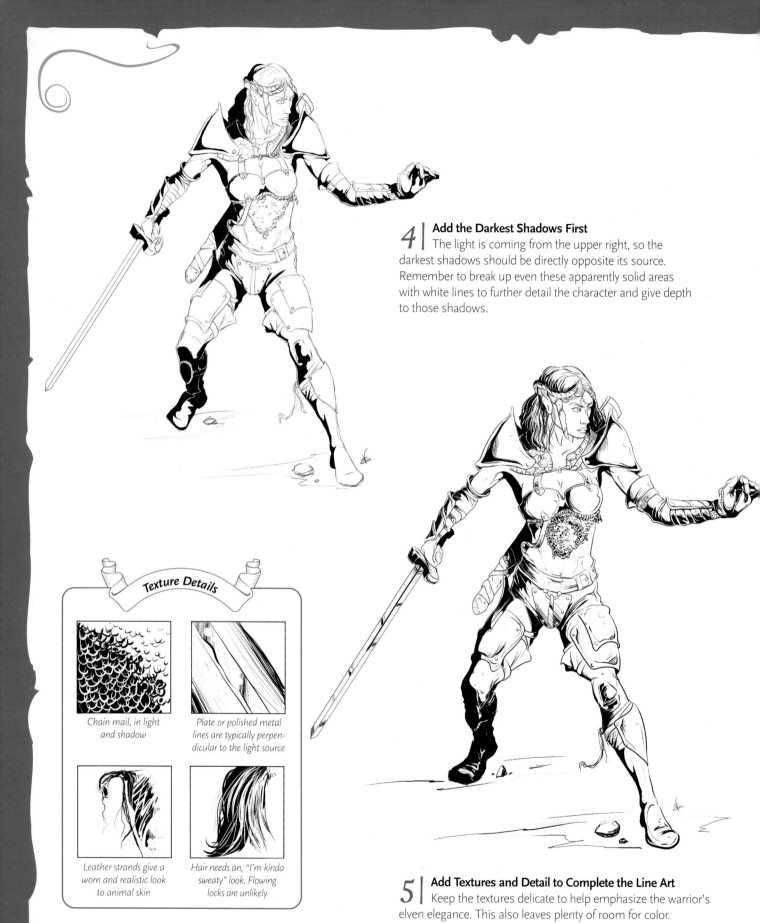

4 | Add the Darkest Shadows First

The light is coming from the upper right, so the darkest shadows should be directly opposite its source. Remember to break up even these apparently solid areas with white lines to further detail the character and give depth to those shadows.

Texture Details

Chain mail, in light and shadow

Plate or polished metal lines are typically perpendicular to the light source

Leather strands give a worn and realistic look to animal skin

Hair needs an, "I'm kinda sweaty" look. Flowing locks are unlikely

5 | Add Textures and Detail to Complete the Line Art

Keep the textures delicate to help emphasize the warrior's elven elegance. This also leaves plenty of room for color.

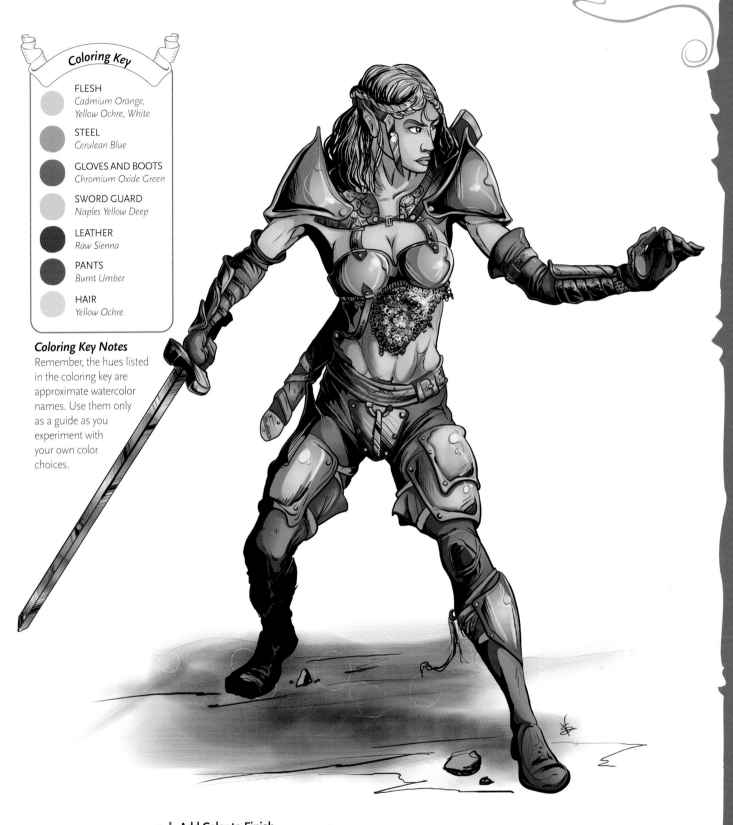

Coloring Key

FLESH
Cadmium Orange,
Yellow Ochre, White

STEEL
Cerulean Blue

GLOVES AND BOOTS
Chromium Oxide Green

SWORD GUARD
Naples Yellow Deep

LEATHER
Raw Sienna

PANTS
Burnt Umber

HAIR
Yellow Ochre

Coloring Key Notes

Remember, the hues listed in the coloring key are approximate watercolor names. Use them only as a guide as you experiment with your own color choices.

6 | Add Color to Finish

I picture half-elven warriors as very rangerlike in color; lots of earthy tones, with a well-worn appearance. These characters are graceful, poised and dangerous all in one package.

Keep in mind that common materials have a constant color range—leathers are red to brown and black—while cloth is typically lighter with green and tan. Metals are often gray/blue based.

Knights

Knights are the elite. Whether they attained their rank through proofs of their fighting skills or their families' social status, they are the cream of the fighting crop. They are guardians of the realm, traveling the lands of their kings and queens to maintain order.

1 | Begin With Seed Sketches
Knights are often thought of in guarding or fight poses. As you design the knight, keep in mind the primitives that will make him up.

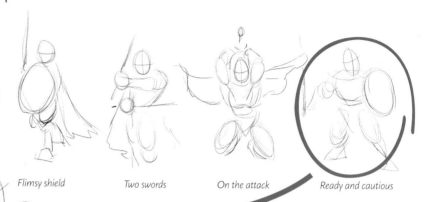

Flimsy shield *Two swords* *On the attack* *Ready and cautious*

2 | Develop the Primitive Drawing
The knight's leg is behind him so he can brace himself should anyone try to rush him or run him down with a horse. Draw the stance as you did the warrior's. Stack sweeping circles to form the limbs and the basic structure of his body, foreshortening as needed. He is slightly bent forward and is poised on the side of his foot. Allow the cape to billow out to provide a feeling of movement.

3 | Develop the Drawing
Leave some of the primitive lines to provide some contour guides to use when you add metal reflections.

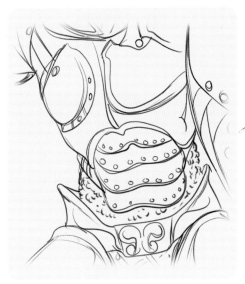

Study Muscle Anatomy to Draw Armor

Follow the sections of muscle groups to create the organic-looking armor commonly worn by fantasy characters. You can either draw the muscles in detail or just block in the main shapes. Either way, make sure you have a solid foundation of muscle groups to follow.

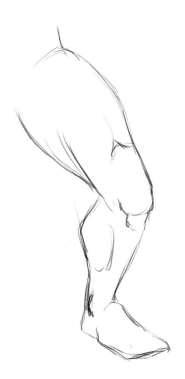

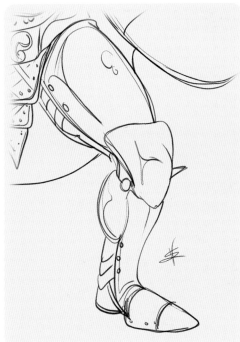

Draw Other Armor

Follow the same procedure as for the chest to draw armor for legs, arms, hands, head or back. Look online for anatomy references to practice with.

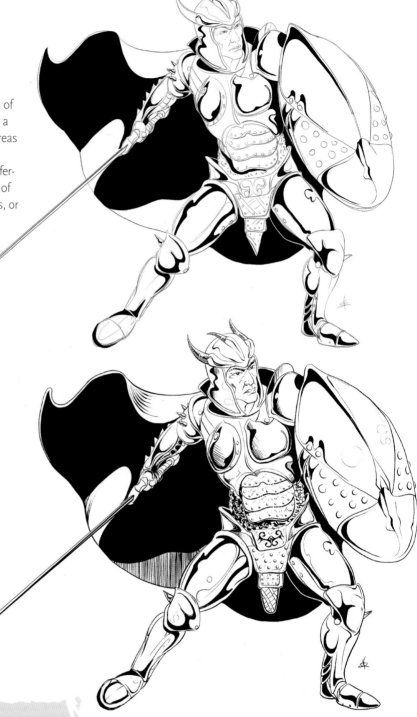

4 | Fill In the Darks

Add a huge shadow in the cape for drama.

Create the reflections on the metal with solid lines of varying thickness using an art pen, a technical pen or a brush. Those lines represent the reflections of dark areas surrounding the knight.

To fine-tune the chrome effect, find some good reference photos of chrome objects similar to the shapes of the body armor. Look at the chrome bumpers on cars, or even the wheel wells. I used photos of the smoke-stacks on a big semi truck for the knight's leg and arms.

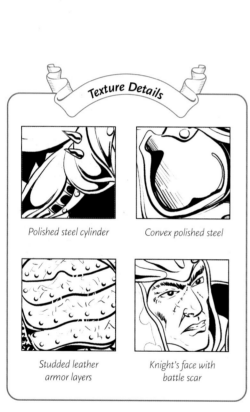

Texture Details

Polished steel cylinder

Convex polished steel

Studded leather armor layers

Knight's face with battle scar

Carry a Camera

Look for references before you begin inking or adding darks. Carry a camera with you so that when you find something that makes you think, "Wow, I bet that would make a really good reference photo for..." you'll be ready. Before you begin drawing a particular character or armor, look through your collection of reference photos for just the right item.

5 | Add Texture Details

There are a number of patterns on medieval armor, usually signifying the house, family or metal-smith. Magical armor often is decorated with runes and other mysterious symbols, especially along blades or shields.

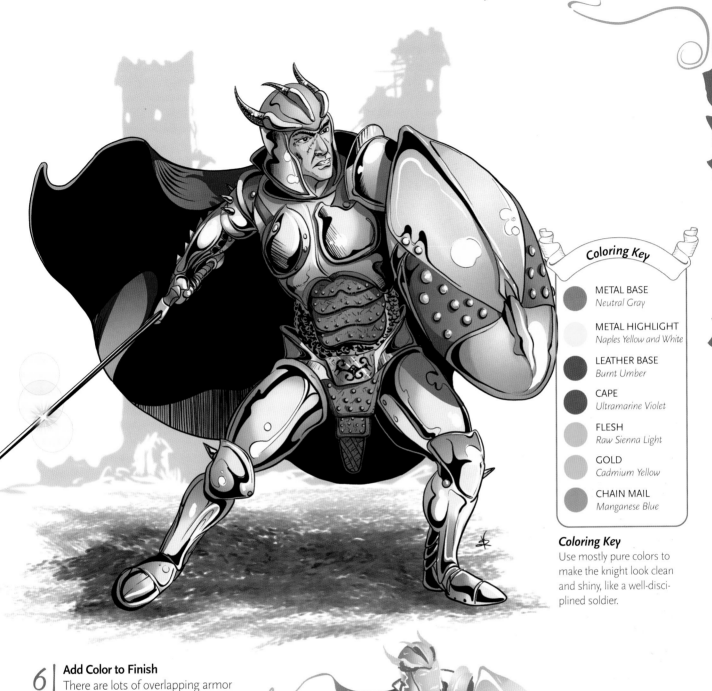

Coloring Key

	METAL BASE
	Neutral Gray

METAL HIGHLIGHT
Naples Yellow and White

LEATHER BASE
Burnt Umber

CAPE
Ultramarine Violet

FLESH
Raw Sienna Light

GOLD
Cadmium Yellow

CHAIN MAIL
Manganese Blue

Coloring Key
Use mostly pure colors to make the knight look clean and shiny, like a well-disciplined soldier.

6 | Add Color to Finish
There are lots of overlapping armor pieces and body parts here, so watch where you're placing cast shadows, both on the ground and on the body itself. Make the final highlights pretty solid, without much gradation. The harder or more polished the surface, the more distinct the highlight should be, with little to no merging with the base colors.

Color From Light to Dark
No matter what colors you use, begin with the light colors and end with the darker ones. The ink layer adds the illusion of complexity.

Princesses

Nearly all folklore traditions have princesses. Our princess will be a noble one with beauty, power and style. Princesses come in as many varieties as demons, with personality extremes like warriors.

1 | Create Seed Sketches

While those of royal heritage often become warriors, royalty also must do its share of meeting and greeting. This leaves room for more static poses. Try one here. Make her wardrobe something stunning.

Just walking through; looks too much like a nun

With a scepter; too wizardish

Waiting for worshippers

Diplomatic and powerful

My original idea for the head-piece was a cloth with dangling symbols, but I felt that a solid headpiece worked better.

2 | Develop the Primitive Sketch

I picked the last seed sketch because that princess seemed much nicer than the others. At her request, however, we have dropped the scepter. Her headpiece is more like a tiara made of stained glass with gold and jewels.

It's important at this point to draw primitives of her figure. Even though you won't see her legs through her gown, it is still essential to draw them to help the cloth flow correctly.

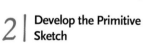
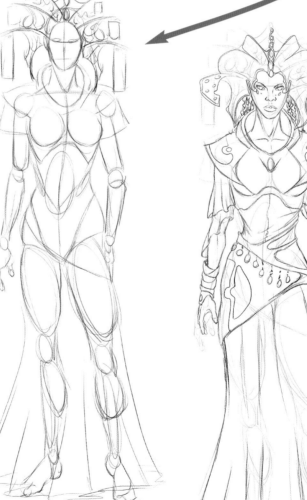

3 | Develop the Drawing

In place of the scepter, add a subtler symbol of strength such as a snake bracelet. Draw the gown so that it flows naturally over her legs.

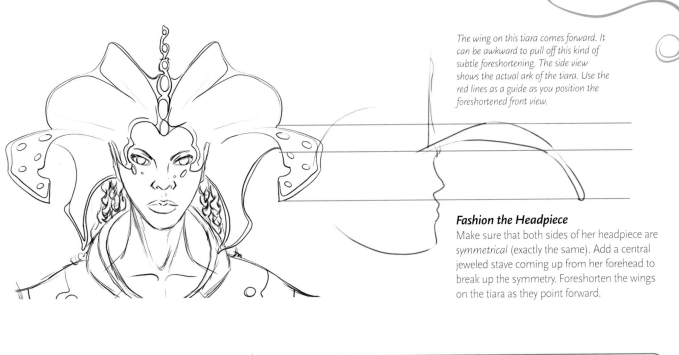

The wing on this tiara comes forward. It can be awkward to pull off this kind of subtle foreshortening. The side view shows the actual ark of the tiara. Use the red lines as a guide as you position the foreshortened front view.

Fashion the Headpiece

Make sure that both sides of her headpiece are *symmetrical* (exactly the same). Add a central jeweled stave coming up from her forehead to break up the symmetry. Foreshorten the wings on the tiara as they point forward.

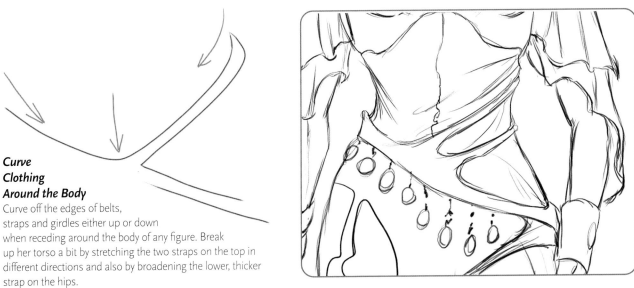

Curve
Clothing
Around the Body

Curve off the edges of belts, straps and girdles either up or down when receding around the body of any figure. Break up her torso a bit by stretching the two straps on the top in different directions and also by broadening the lower, thicker strap on the hips.

Depict the Sweep of Her Gown

Draw the bottom wavy line first, then draw sweeping lines coming up from there. Review pages 34–35 if you need to.

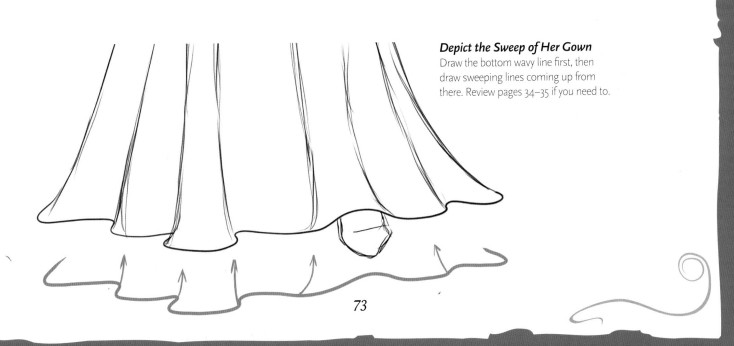

4 | Add the Darkest Shadows

Because the figure is in ambient, diffused light (see page 23), the limbs are parallel to the body, and the viewer is looking at it straight on, this pose does not create a ton of shadows to worry about. Add small shadows to the inner folds of her gown and anywhere a cast shadow might fall to add a touch of depth to her outfit. Also put in the dark area behind her neck to show her hair hanging down and capture the silhouette of her dangling braids.

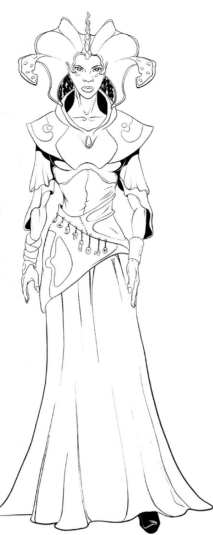

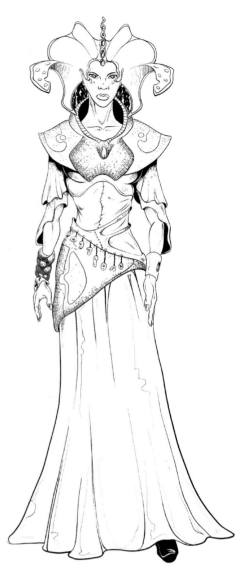

Texture Details

Create these textures using thick, dark lines as well as thin, light ones.

Tightly woven cloth

Snake wrist bracelet

Thin, decorative metal applied to the snake

Gems; on close-ups of faces, do eyes like this, too

5 | Fill In Textures

Add accent marks to the bottom of her gown to show extra movement along the surface. Use very thin lines. Do them quickly, like neat scribbles.

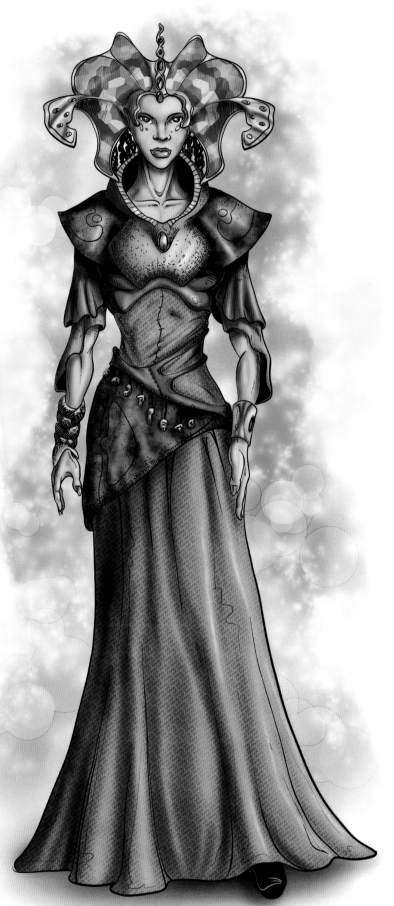

6 | Finish With Color

Arrange the headpiece colors using mixtures from the coloring key, along with a Cadmium Yellow hue. If you color with anything other than a computer, carefully silhouette the figure with the background before beginning color for the inside.

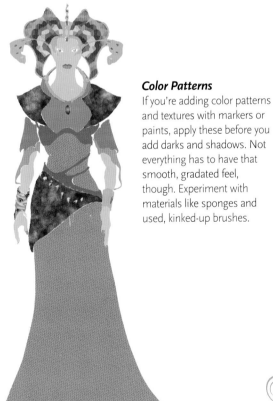

Color Patterns

If you're adding color patterns and textures with markers or paints, apply these before you add darks and shadows. Not everything has to have that smooth, gradated feel, though. Experiment with materials like sponges and used, kinked-up brushes.

Magic-Users

Magic-Users may either be good or evil. Each type of magic-user is subtly different in abilities and methods. Here's a general overview of the different types.

➤ Wizards are usually book-oriented and use the natural magic energy within themselves. They are usually good guys.

➤ Sorcerers are typically associated with dark magic. They do a lot of summoning and channeling of the forces of nature.

➤ Warlocks and Witches are practitioners of natural magic that pertains to the elements.

➤ Necromancers are defiantly evil. This type deals with the living dead and the underworld.

➤ Enchanters are generally neutral. They channel energy into objects and imbue scrolls with spells for the average person to use.

➤ Magi (plural of mage) are much like wizards, but a bit more studious and theosophical.

➤ Druids are magic-user and healer combinations that are in tune with nature. You'll often find druids as caretakers of communities or villages.

1 | Begin With Seed Sketches
We're going to draw a sorcerer. The typical sorcerer stance is one of casting magic of some kind with staff in hand.

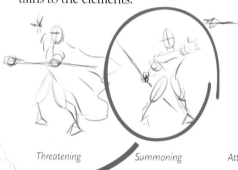

Threatening *Summoning* *Attacking with a spell* *Opening a gateway with a crystal ball*

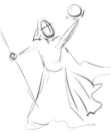

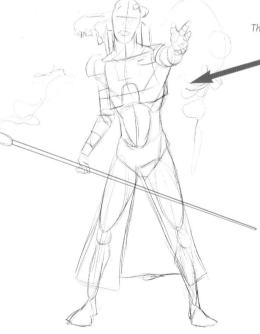

2 | Develop the Primitive Sketch
I went with the summoning guy. Just looking at him makes you wonder who is he casting at. Take special care when foreshortening the outstretched hand facing the viewer with overlapping spheres.

3 | Develop the Drawing
Mohawk ponytails and an Egyptian-inspired staff make this guy stand out from other sorcerers.

Show Movement With the Head

Make sure the head tilts to the right as the tails go left. This gives movement to an otherwise still figure. Squint the eyes to imply focus and have his mouth open to give the impression of vocalizing a spell.

Use Concentric Circles to Create a Foreshortened Hand

Concentric circles are great for drawing through what is hidden by what's in front. They help maintain a realistic contour (the outside part of the circles that you use in the drawing for outline) that the viewer can understand as coming toward them. You can draw nearly any foreshortened limb with concentric circle perspective.

The illusion of movement in the fingers adds more life to the figure, especially since it corresponds to the movement of the head.

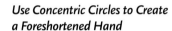

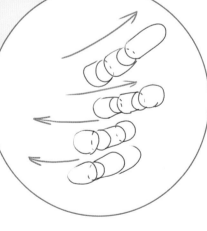

Create Clothing That Conforms to the Body

Clothing must conform to and move with its wearer. Even armor-type pieces like the armband must curve with the arm. Use lots of sweeping lines to simulate the movement of the sorcerer's clothing. And remember, where a joint bends, the clothing must bunch up. Wherever you have a joint, begin the sweeping lines at the bend and move outward.

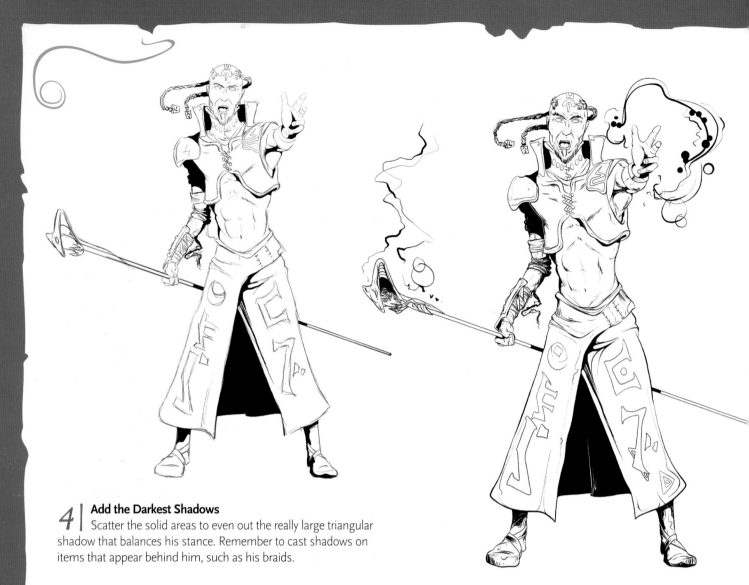

4 | Add the Darkest Shadows

Scatter the solid areas to even out the really large triangular shadow that balances his stance. Remember to cast shadows on items that appear behind him, such as his braids.

5 | Fill In the Textures

Draw curvy, wavy lines from the sorcerer's hands and from his staff to tell the viewer that something is happening in the air. Use contour sweeps and accent squiggles to put in subtle texture impressions. Add a visual emphasis of some sort, either lines or shadows, anywhere clothing meets. The magical runes on his dress can be anything; make them up or use ancient script.

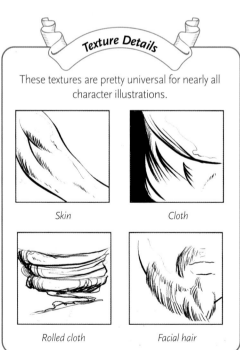

Texture Details

These textures are pretty universal for nearly all character illustrations.

Skin

Cloth

Rolled cloth

Facial hair

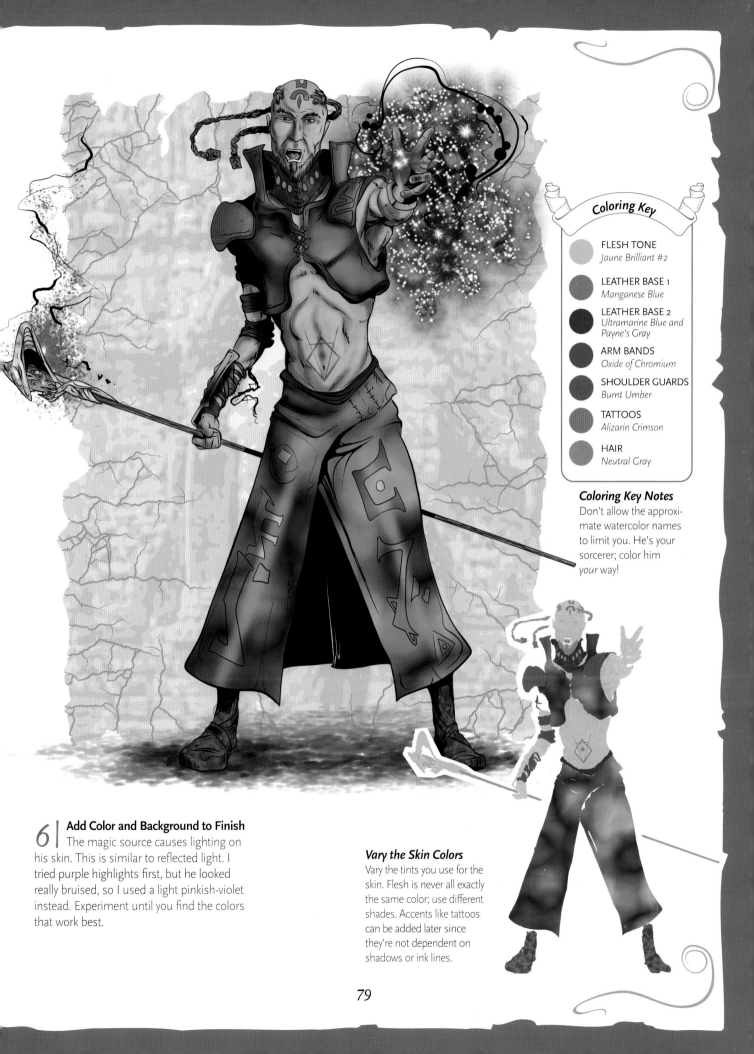

Coloring Key

FLESH TONE
Jaune Brilliant #2

LEATHER BASE 1
Manganese Blue

LEATHER BASE 2
Ultramarine Blue and Payne's Gray

ARM BANDS
Oxide of Chromium

SHOULDER GUARDS
Burnt Umber

TATTOOS
Alizarin Crimson

HAIR
Neutral Gray

Coloring Key Notes
Don't allow the approximate watercolor names to limit you. He's your sorcerer; color him your way!

6 | Add Color and Background to Finish
The magic source causes lighting on his skin. This is similar to reflected light. I tried purple highlights first, but he looked really bruised, so I used a light pinkish-violet instead. Experiment until you find the colors that work best.

Vary the Skin Colors
Vary the tints you use for the skin. Flesh is never all exactly the same color; use different shades. Accents like tattoos can be added later since they're not dependent on shadows or ink lines.

Faeries

In nearly every society of the world there are tales of forest-dwelling earth care-takers. They are called faeries (also spelled *fairies*). They are perceived as both mischievous and helpful and there are as many types of *fae* (faery kind) as there are people in our world. Elves are directly related to faeries and both are part of the fae kingdom. They are intimately attached to the elements: earth, water, fire and air. In this demo we'll create a traditional forest or garden faery.

1 | Begin With Seed Sketches

I often visualize dancers when drawing faeries.

In your face Hovering Relaxing Getting blown away

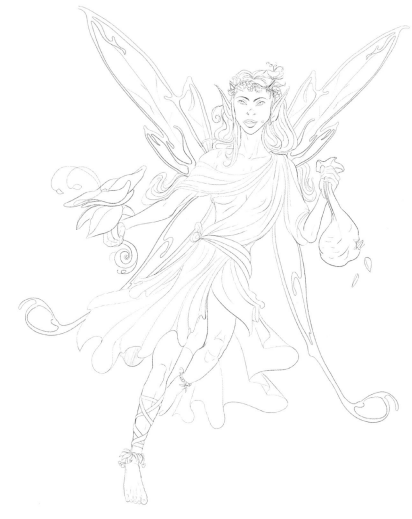

2 | Develop the Primitive Sketch

The hovering faery gives us the chance to do a full portrait-style picture. Use circle stacking to block out the basics. Erase your interior sketch lines before beginning the clothing so you don't confuse the lines.

3 | Complete the Drawing

Elaborate lines give this faery an art nouveau air. Make her clothing very loose and fluid. Use sweeping lines anywhere her clothing bunches.

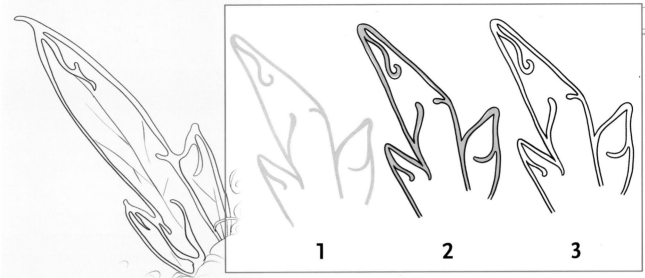

Create the Outlined Wing

1 Draw the shape in heavy marker on plain white paper.

2 Place a piece of tracing paper over the marker drawing. Use a soft drawing pencil to trace the inside and outside of the marker lines. Press fairly hard on the pencil, being careful not to tear the paper.

3 Turn your tracing paper over and line it up where you want it to go on your drawing surface. Then trace over your pencil lines again, pressing hard on your pencil and being careful not to tear the paper. The graphite from your paper should transfer. Now just go over the graphite lines with ink.

Repeat One Design for the Headpiece

Her headpiece appears complex, but it is really just a simple design repeated several times.

Complete the Bunched Clothing on Her Torso

Follow the arrows to draw the flow of bunched clothing. Another way of looking at it is that it's like drawing oblong balloons stuffed into a belt. Think of how water flows and have it flow around the loops you create.

Continue each fold until its end; don't leave any open-ended unless you plan to complete it in the color stage.

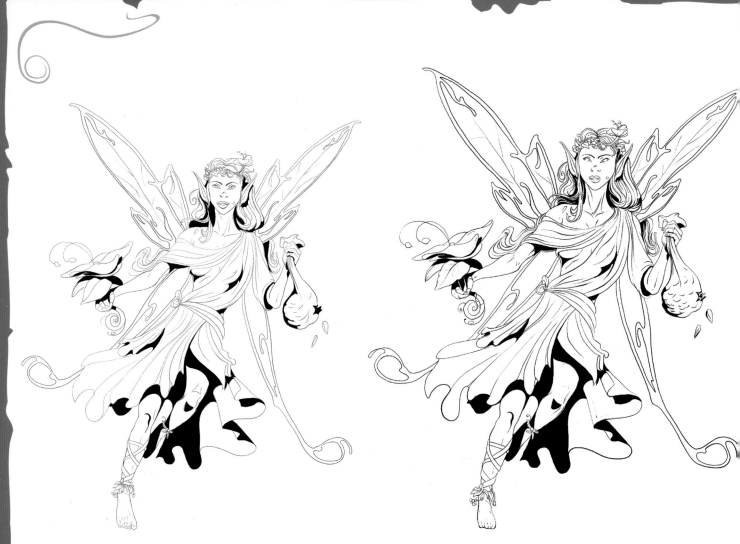

4 | Fill In the Darkest Shadows

Fill in darks underneath things such as her flower, her bag of coins and clothing folds. Don't add shadows on her wings, as those will be translucent, much like butterfly wings.

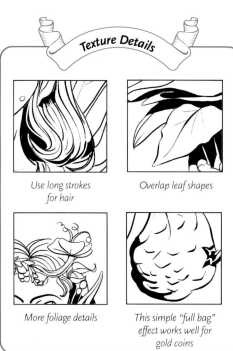

Texture Details

Use long strokes for hair

Overlap leaf shapes

More foliage details

This simple "full bag" effect works well for gold coins

5 | Add Texture and Fill In Shadows

For the delicate lines and finer shadows, use lines that are thinner than usual to help the figure have a softer and more fragile appearance.

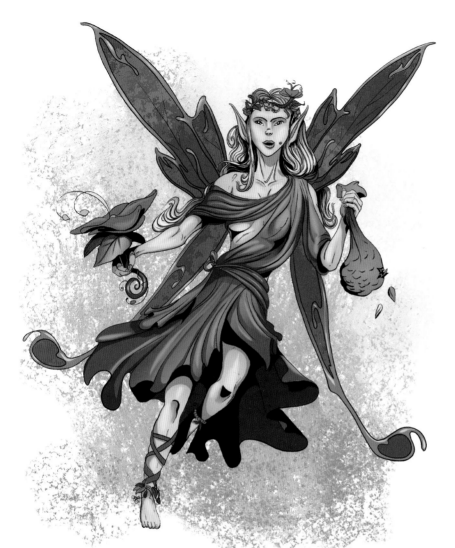

Coloring Key

FLESH
Jaune Brilliant #2

HAIR
Naples Yellow Deep

WINGS *Magenta and Manganese Blue*

DRESS
Viridian

FLOWERS
Choose any colors you like

BAG
Burnt Umber

BERRIES
Deep Red

6 | Add Color to Finish

Apply the highlights very gently to give the faery a soft feel. Compare this with the warrior or the knight to see what I mean.

Use Lots of Variety

Sometimes the more colors you add, the happier your character looks. Don't be afraid to go crazy with faeries.

Use Darker Shades for Shadows

Use slightly darker shades of colors to indicate shadows without resorting to black.

83

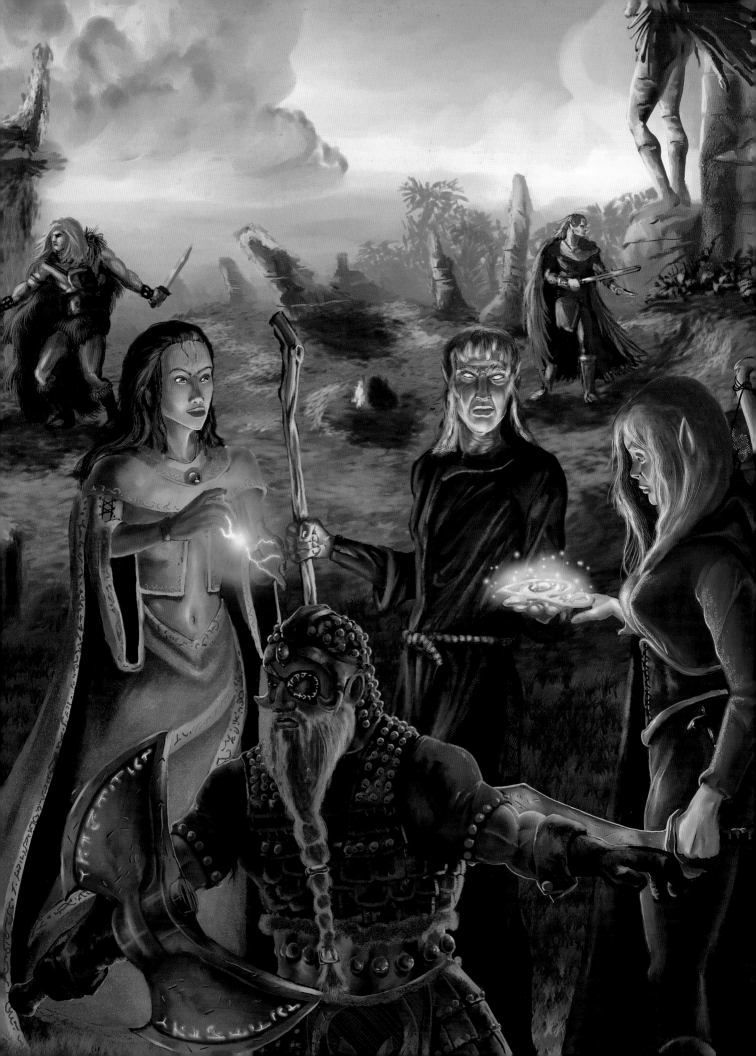

The Settings

Creating convincing fantasy environments is one of the most exciting things to tackle. The setting establishes the style and mood for the story and the characters. A battle between a lone warrior and a horde of goblins wouldn't feel the same if it took place in a field of flowers on a sunny day as it would if the warrior stood at the top of a staircase descending into a web-infested ruin, the scene illuminated by a single shaft of light.

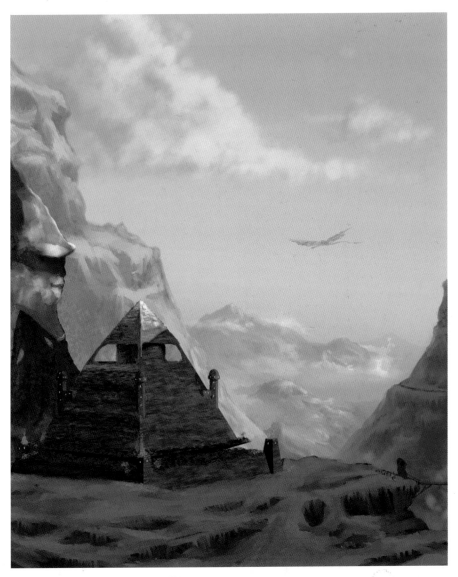

Castles

After a decidedly long journey, you spy a castle atop a hill. You think this odd, since you encountered no peasants or knights about the land. Perhaps the castle is abandoned. Before going farther, you decide to take a brief rest on the rock up ahead. You take out your journal sketchbook (which we both know you carry everywhere) and sketch the castle, adding it to your travel log to show where you have ventured.

1 | Begin With Seed Sketches
Often for castle inspiration, I check out books on castles and even check online, search word: European castles.

Nice, but no front view *A good perspective approach* *A good bird's-eye view* *Somehow, this doesn't seem as interesting a place*

2 | Develop the Primitive Sketch
One of the advantages of drawing buildings as opposed to people is that it's a bit easier to figure out the primitives because they are more obvious in the structure.

3 | Develop the Drawing
This drawing is made up mostly of combinations of dots and lines. Its complex look is just the result of patience and attention to details.

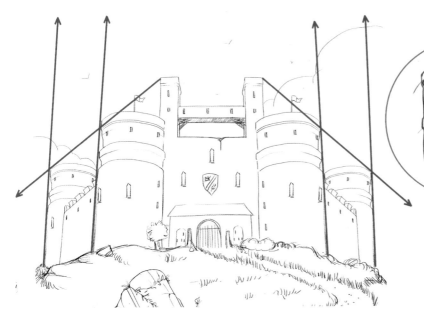

Use Cylinders for the Towers

Draw the concentric rings all the way through to achieve a sense of solidity.

Use Three-Point Perspective for the Castle

Three-point perspective allows the viewer to look up at the castle from the rock and get a sense of its height. Eventually, the lines of the towers would converge to a vanishing point far, far away.

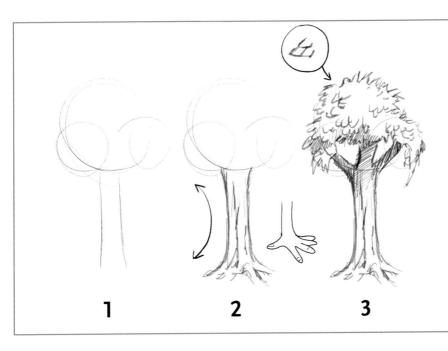

1 **2** **3**

How to Draw the Trees

1 Draw circles for the number of bunches of leaves you want on your tree. Then, much like a lollipop stick, draw the trunk extending down from the largest bunch.

2 Look at the roots of any tree, doesn't it remind you of fingers stretched out on a hand? Draw roots as if they are fingers.

3 Depict the leaves as little diamond shapes or V-shapes, depending on the type of tree you want.

Draw Rocks and Grass

For grass, draw lines out and upward like a bad hair day. Give them breadth with sides to complete the blades. Rocks can be just simple oblong sketches.

The carved stone block here is used as a perspective marker in a worm's-eye view to give the feeling how far away the castle is (see pages 25–26).

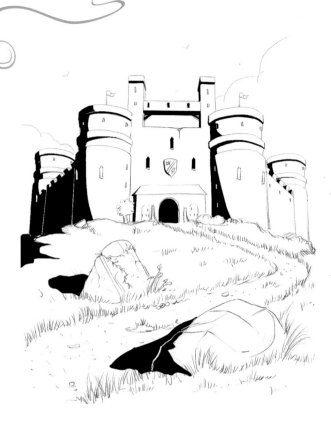

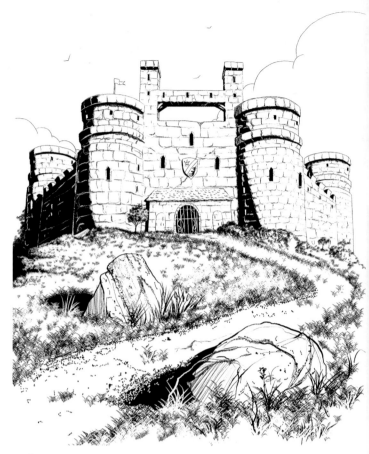

4 | Apply the Darkest Shadows

Leave some white lines in the shadow areas to help show the form. You can add extra white lines in dark areas with a white correction pen.

5 | Add Texture and Shading

This is where all the fun begins: in details, details, details! Use short upward strokes to suggest grass blades, staggering them to make the grass appear more natural. Everything else here is made up of staggered lines and dots.

Castle Blocks

A simple approach to blocks repeated over and over again allows you to add a keen amount of detail pretty easily. Add curved chisel marks to the square blocks to suggest fullness.

Block Arrangement and Shading

Arrange the blocks in an alternating pattern. Make the areas where the stones meet darkest, gradually lightening the ink lines toward the center by breaking the lines into dots and scratch marks.

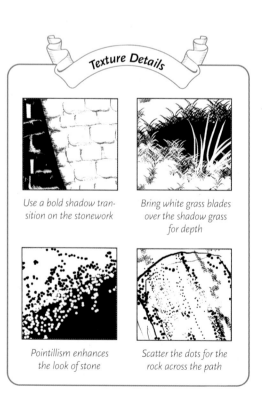

Texture Details

Use a bold shadow transition on the stonework

Bring white grass blades over the shadow grass for depth

Pointillism enhances the look of stone

Scatter the dots for the rock across the path

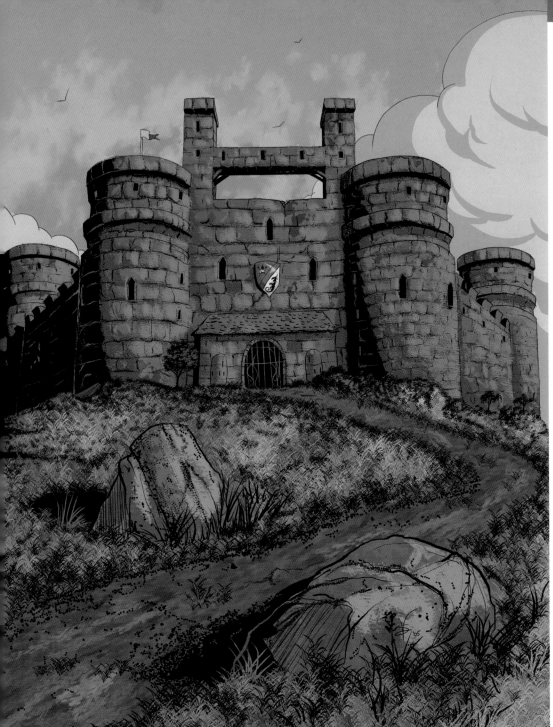

Coloring Key

● SKY
 Cerulean Blue

● CLOUDS
 Jaune Brilliant #1

● CASTLE STONE
 Sepia Tone

● GRASS
 Greenish Yellow

● DIRT TRAIL
 Burnt Umber

● COAT OF ARMS SHIELD
 Emerald Green and Deep Red

● FOREGROUND STONES
 Neutral Gray

Coloring Key Notes

Remember, all color names are approximate. Feel free to match the color swatches with what you have on hand.

6 | Add Color to Finish

Vary the colors and values on all the sky, grass, walls, roads and rocks. Value changes, even slight ones, will add excitement to your picture.

Bumpy

Nearly smooth

Highlighted

Vary the Values for Stone Surfaces

Stone surfaces are rarely smooth. Pick up any rock and you'll see that it's full of indentations. Different values of the same hue can illustrate the different levels of the stone surface. The sharper the indentation, the greater the contrast in values. Polished stone, such as that used for statues and pillars, will often reflect light, causing sharp highlights.

Castle Interiors

Upon reaching the abandoned castle, you find the main gate unlocked and the path clear to a large room with a vaulted ceiling. There are no signs of recent battle or conflict. It's as if everyone in the castle just disappeared.

Interiors are confusing to sketch randomly, so seed sketches aren't as useful. They would just turn into a jumbled mess, like a pile of boxes in a warehouse. To really get any feeling for what you want to convey, these kind of sketches need to be more fully rendered. Dive right into looking for your basic shapes.

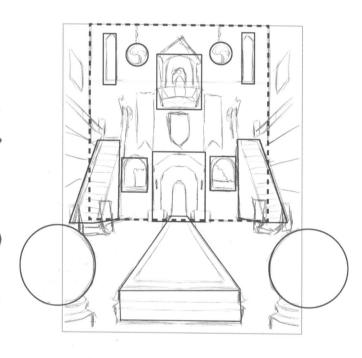

Use Basic Shapes to Develop Your Sketch
Interiors are made up of the same basic shapes as exteriors.

1 | Develop the Primitive Sketch
Turn the circles into the spherical caps atop the stone balustrades right and left at the front, giving the viewer the feeling he has just stepped into the room. Work on the picture section by section, making minor adjustments to the shapes to turn them into the steps, hallway, windows and lamps (magic lamps, of course!).

Symmetry Trick
Draw only half of the image, but draw it well. Then copy the image using a scanner or photocopier. Flip the copy to the other side (copied side down) and put it underneath the paper with your original drawing. Trace over the copy to complete the image. A light table will make this process much easier.

2 | Complete the Drawing

It's of more interest to your viewer that you create a high level of detail for the interiors if this is your main focus with no characters. Draw the "little things" you would notice walking through someone's house—pictures on the walls, statues, shields, maybe even something discarded on the floor. And remember your perspective, the closer to the viewer the larger it is, the farthest away gets gradually smaller (in this case the stairs) which leads your viewer further into the piece. Leave the bulk of the textures and rendering for the next stage.

3 | Fill In the Darks

The darkest darks here are in the hallways. Be sure to fill in the few other black shadows, such as the shadow sides of the stairs.

Add Lines to Enlarge Your Castle

Imply more rooms and staircases beyond the main entrance with just a few simple lines.

Create and Use Standard Patterns

Create a couple of different patterns for things like windows and archways, then use those consistently throughout the structure.

Lamp Details

Use fine lines for the lamp and its art nouveau styling.

4 **Fill In the Textures and Shadows**

Again, work one section at a time to fill in the textures. Avoid making any lines too straight to add an old and worn feeling to the castle.

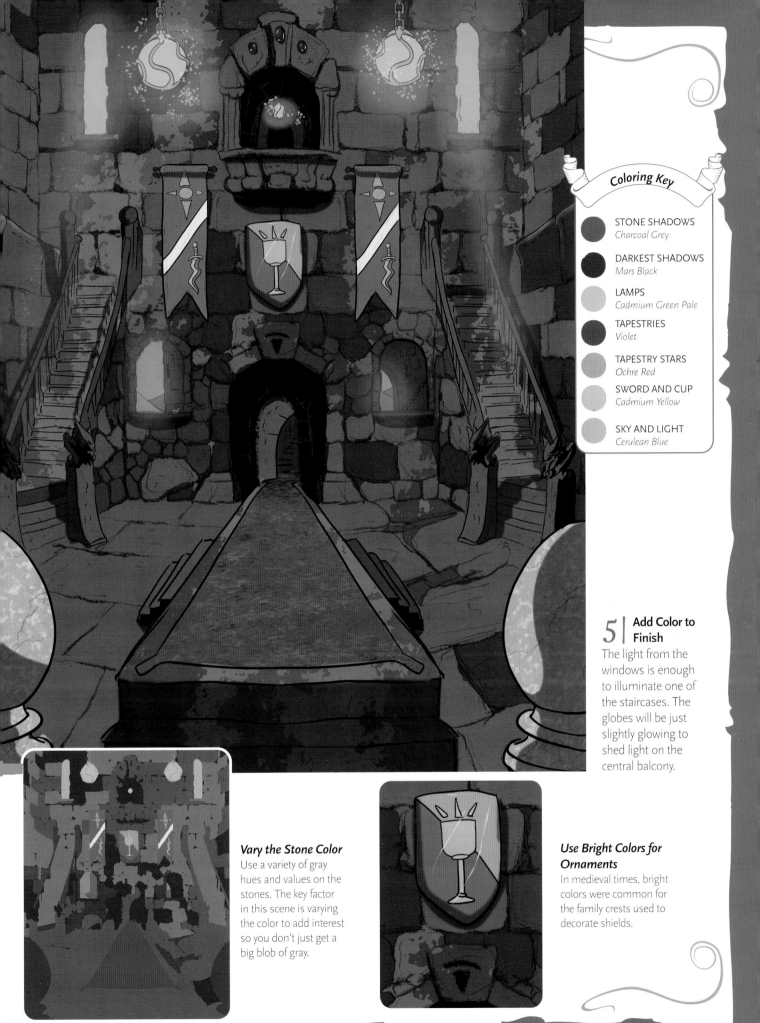

5 | Add Color to Finish

The light from the windows is enough to illuminate one of the staircases. The globes will be just slightly glowing to shed light on the central balcony.

Vary the Stone Color

Use a variety of gray hues and values on the stones. The key factor in this scene is varying the color to add interest so you don't just get a big blob of gray.

Use Bright Colors for Ornaments

In medieval times, bright colors were common for the family crests used to decorate shields.

Ruins

An abandoned city sits high in the mountains. Within its crumbled walls is but one clue to its demise: the giant, sun-bleached skeleton of a long-forgotten monster.

Ruins are favorite settings for adventure stories. They lend themselves to mystery, hinting at danger while concealing magic devices and treasures.

It's best to begin ruins as perfectly good structures, and then go about ruining them. In other words, you'll create a sketch of a perfectly good structure, then mess it up.

The colors of ruins lean mostly toward desert tones, so you'll have to make the most of your light, shadow and textures. You'll also want to get an idea of where highlights will go before you begin any shading or coloring. So study the finished piece to decide where you must save light areas in the early stages.

Nice view, but too much in profile

Better view with staggered symmetry and dark openings

Too symmetrical; not enough depth or perspective markers and still too menacing

Nice view with lots of corridors

1 | Begin With Seed Sketches
Think about all the archaeological documentaries you have seen as you begin your sketches.

2 | Develop the Primitive Drawing
The sketch with staggered symmetry provides lots of potential for light and shadow. Add the skeleton of the collapsed creature and some human skeletons for perspective markers. This critter looks like he was pretty big!

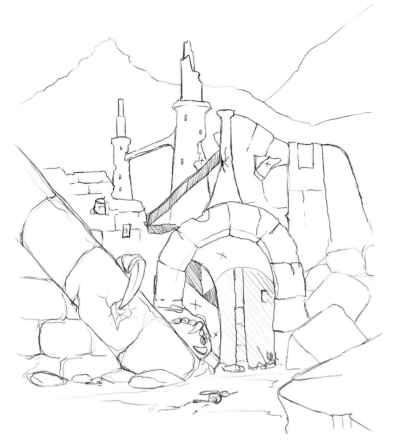

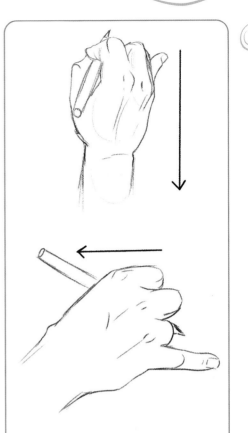

3 | Complete the Drawing

Now that everything is blocked in, begin very roughly sketching in the details. Often a rougher sketch gives a more authentic feel to ruins.

Indicate the areas of darkest shadows that will need solid shading with X-marks in light pencil. Place the skeleton where the arch and the fallen pillar intersect; this will be the main focus of the piece. Make sure all your main elements direct the viewer's eye this way. The angles of the rocks, even some of the corners of rocks and the curve of the arch should all point to the skeleton.

How to Draw a Straight Line Without a Ruler

Hold your drawing tool as you would normally. Stick out your pinky finger. Gently balance the weight of your hand on your pinky and pull back with your whole arm (mainly the upper arm between the shoulder and elbow). This technique works especially well with a brush.

The more you practice this technique, the more you'll be amazed at how handy it is.

How Things Fall Apart

Buildings disintegrate in a fairly predictable way. The tops of the walls are usually the first to crumble, leaving behind the foundations or the cornerstones.

Take out chunks of the thinner areas and any protrusions. If the ruins are in a green environment, add weeds and vines all over. If they're in a desert, add piles of dirt and sand.

Don't Use a Ruler for Ruins

Using a ruler for ruins makes them look too modern.

Trust Your Hand

Sketching by hand lends a more natural feel.

4 | Fill In the Darkest Shadows

Add a solid shadow anywhere you had an X-mark. Make sure all the shadows are cast in the same direction.

5 | Develop the Shading

Use diagonal hatch lines for the secondary shadow areas that fall midway between light and dark.

6 | Finish the Textures and Details

Apply the textures as shown in the texture detail key. Approach only one section at a time (column, arch and so on). Before you know it, you'll have more detail than you originally thought you would have patience for!

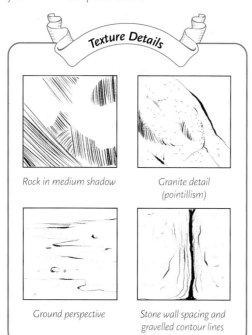

Texture Details

Rock in medium shadow

Granite detail (pointillism)

Ground perspective

Stone wall spacing and gravelled contour lines

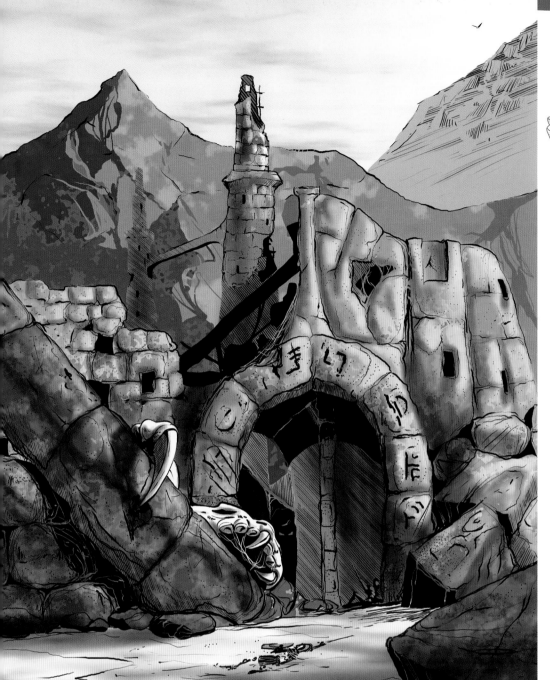

Coloring Key

MAIN STRUCTURE
Gamboge Hue

FOOTHILLS
Olive Green

HILLS ACCENT
Hooker's Green Dark

FOREGROUND
Yellow Ochre

DISTANT MOUNTAIN
Turquoise Blue

**COLUMN AND
STONE WALL**
Neutral Gray

SKELETON *Naples
Yellow and White*

7 | Add Color to Finish

If you are working with watercolors or markers, be sure to save the highlights. Add reflected light on the stones (especially on the column), as the ground will reflect sunlight onto the stone and make it appear lighter.

Keep Your Colors Simple

Your ruins can look finished and believable with even simple blocks of color like these. To maintain sharp divisions between light and shadow, use fine-tipped markers. If you're using paints, use masking fluid (frisket), which is available at art supply stores.

Easy Techniques to Get a Complex Look

Lay down solid color first, then use a digital filter to create noise. Or if you're painting, dab over it with a sponge after its dry. You could even put in some spattering like a toothbrush speckle effect.

Villages

Most fantasy characters eventually must visit a village or town. Before you start drawing yours, play with some models to help you get in the 3-D head-space necessary to draw your village in perspective. Gather empty milk or juice cartons (the cardboard quart ones; and rinse them out first), boxes of various sizes, empty soda or water bottles, toilet paper rolls and anything else that might stand in for a building. Armed with your impromptu model set, arrange your village in a large clearing in your garage, yard or living room. Set it up, walk around, look at it from different angles and rearrange it as you see fit. Sketch it in a few different setups and from a few different angles to give yourself ideas to choose from.

While villages and towns are necessarily filled with people, it's a good idea to draw the entire scene before placing the residents. You can make little ovals (like hot-dog-shaped balloons) to designate where your people will be standing, but make sure you have the basics of the town down before you fill in the people.

1 | Begin With Seed Sketches
For these kinds of pictures, I often turn to the Internet for ideas for villages in specific countries. You might even check your local library for information on other cultures in lands with ancient appeal.

Too far on the outskirts

Looks like we're trying to sell space at a craft show

Not bad, but the tower is too dominant

Entering the village, nice

2 | Draw the Primitive Sketch
You're entering this small mountain village by one of the main roads, which is lined with a few artisan kiosks. Draw the basic shapes: triangles, cones, oblongs and squares. At this point, just concentrate on getting the perspective and proportions right.

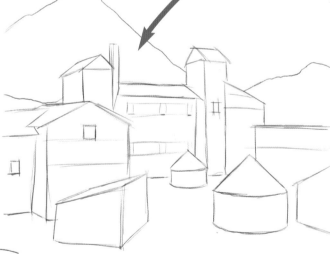

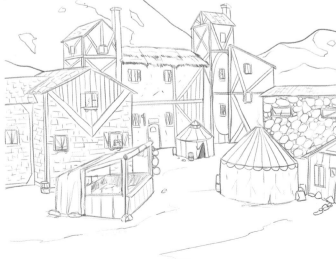

3 | Develop the Drawing
Fill in the details one section at a time. Most fantasy villages have an old-world style. The builders of that time couldn't hide the wooden beams they built with (no siding), so they got creative with them. Draw the wooden slats in different angles and patterns to give your village an authentic feel.

Village Perspective

Two-point perspective should be sufficient for such a small village.

Don't Line Up Your Buildings

A single-view, straight-on shot is not very interesting. Scramble the buildings and perspective around a little bit to add variety.

Base Your Designs on Historical Models

These are only a few examples of medieval era village construction. Look online for more. Basing your fantasy worlds on actual historical information will make your creations much more believable.

Fantasy villages always seem to be filled with barrels. Strategically place them on empty corners to break up the space.

Break Up the Edges and Corners of the Buildings

Fill your village with lots of little details to add variety and interest. It doesn't have to be anything complicated. Small touches will make big differences.

Sometimes filling up space is as easy as adding a few blades of grass.

Open windows! Think about what might be going on inside. Add shadows of people, furniture or curtains.

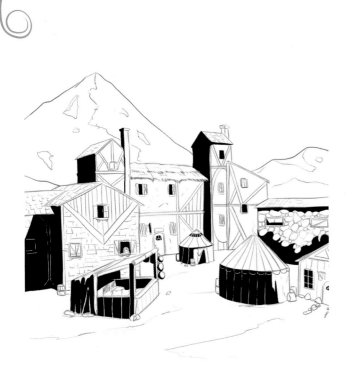

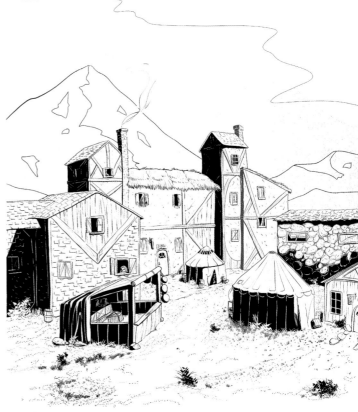

4 | Fill In the Darkest Shadows
Make sure all your cast shadows fall in the same direction. Allow the white space to help define the form in darker areas.

5 | Add Texture Details
Use short, upward strokes to fill in the tufts of grass. Remember to keep it simple and work one section at a time.

Stone Walls
A pile of ovals can appear as a pile or wall of stonework. Add darks where the holes between them appear. Use hatching rather than solid darks to provide shadow.

Wood Grain
Use stringlike strokes and random hatchmarks (see page 18) to create the look of wood grain without a lot of effort.

Roof Tiles
Use short bar sweeps (see page 19) to detail the tiles.

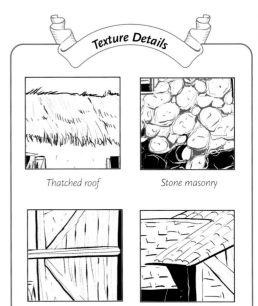

Texture Details

Thatched roof

Stone masonry

Wood panels

Roof tiling

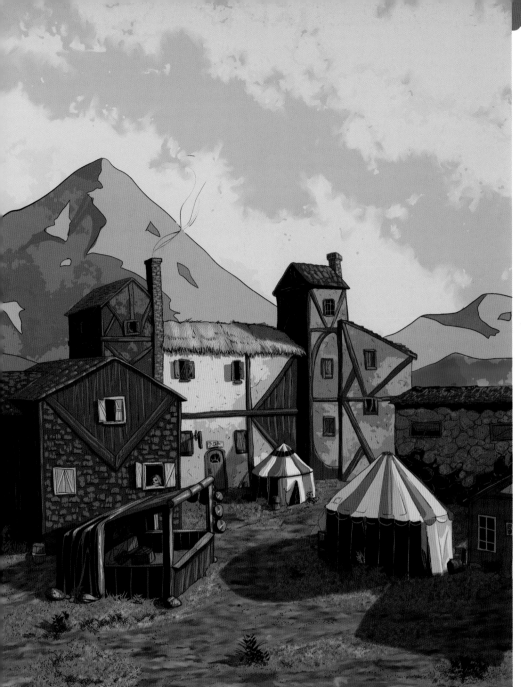

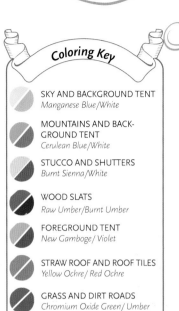

Coloring Key

	SKY AND BACKGROUND TENT *Manganese Blue/White*
	MOUNTAINS AND BACK-GROUND TENT *Cerulean Blue/White*
	STUCCO AND SHUTTERS *Burnt Sienna/White*
	WOOD SLATS *Raw Umber/Burnt Umber*
	FOREGROUND TENT *New Gamboge/ Violet*
	STRAW ROOF AND ROOF TILES *Yellow Ochre/ Red Ochre*
	GRASS AND DIRT ROADS *Chromium Oxide Green/ Umber*

Coloring Key

Colors listed along with white indicate one color used in different shades.

6 | Add Color to Finish

Color the mountains in cool hues without much detail to show that they're far in the distance. Remember to include highlights and cast shadows there, too. All your light should come from the same direction. Use darker hues of the ground and building colors to create believable shadows in the village itself.

Remember the Cast Shadows

Remember to color in the cast shadows for overlapping shapes. The light source is at the top right, so consider which objects will be totally in shadow. Also consider which buildings will throw shadows on other buildings.

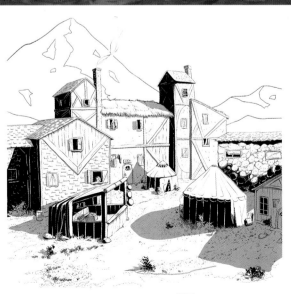

Limited Palettes Work Best for Towns

When coloring a town or village, it's a good idea to use a limited palette, preferably with related colors. This will not only unify your village, but it will also allow any characters or action you place there to stand out more.

Mysterious Towers

After leaving the castle you journey north toward the legendary Mysterious Tower. Getting there looks precarious. How are those rocks floating, anyway?

To get ideas for your own imaginary towers, think about unusual things that you wouldn't see everyday or in history books. Glance through the fantasy section at local bookstores. Some key descriptors you might find there are: *glowing, floating, gigantic, immense, foreboding* or *strange.*

1 | Begin With Seed Sketches
Mystic towers follow the same inspiration as ruins, but add a twist. This could be a crooked tower that seems to defy falling completely or some extreme environment that almost seems to contradict the building itself. Think mystery.

Too high and no ropes *Too much like a model design* *Too spiky and crablike* *Nice, but looks a little like a squid*

2 | Sketch the Primitive Drawing
The model design sketch works if you rotate it so that the tower is more at a three-quarters view.

With a scene this fantastic, you'll need some ordinary items to give viewers a sense of scale. The rope bridges work as perspective markers.

Draw upside-down cones for the chunks of floating land. Form the tower into a sort of needle shape to balance the scene.

3 | Develop the Drawing
Place the billowy clouds and the rocks so they lead the eye to the tower. Make the mountain in the background point in the same general direction as the tower to help offset the floating rocks that point downward.

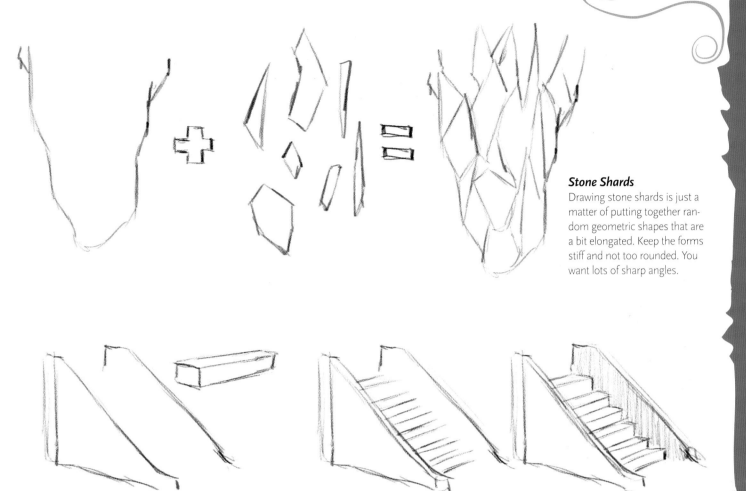

Stone Shards

Drawing stone shards is just a matter of putting together random geometric shapes that are a bit elongated. Keep the forms stiff and not too rounded. You want lots of sharp angles.

Stairs

Flank a series of oblong boxes with a couple of triangles and you've got stairs. Repeat the form of one stair to quickly create the impression of a staircase.

Common Roadway Bridge

This common roadway bridge uses one-point perspective with no arched or concave lines. It's well supported and designed to be sturdy.

Swinging Bridge

This is our bridge. There is no support underneath, so it swoops or hangs. If you were walking across, it would swing. The most concave part is the middle.

Arched Bridge

The arched bridge is common along small streams or creeks. It often has some fancy stone masonry work.

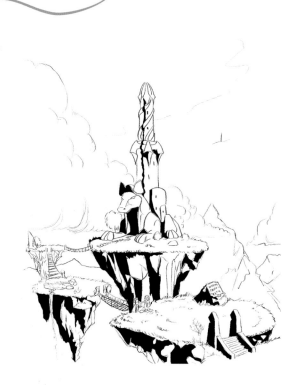

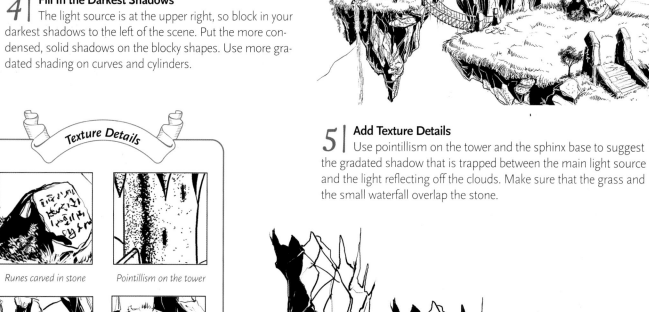

4 | Fill In the Darkest Shadows

The light source is at the upper right, so block in your darkest shadows to the left of the scene. Put the more condensed, solid shadows on the blocky shapes. Use more gradated shading on curves and cylinders.

Texture Details

Runes carved in stone

Pointillism on the tower

Bridge with strands of loose rope hanging down and gaps between each of the planks

Weather-worn stone stairs and grass catching light in the shadow areas

5 | Add Texture Details

Use pointillism on the tower and the sphinx base to suggest the gradated shadow that is trapped between the main light source and the light reflecting off the clouds. Make sure that the grass and the small waterfall overlap the stone.

Scatter Your Shadows

Don't connect all your shadows. Scatter them a little to add visual variety and achieve the effect of light bouncing up from the land below.

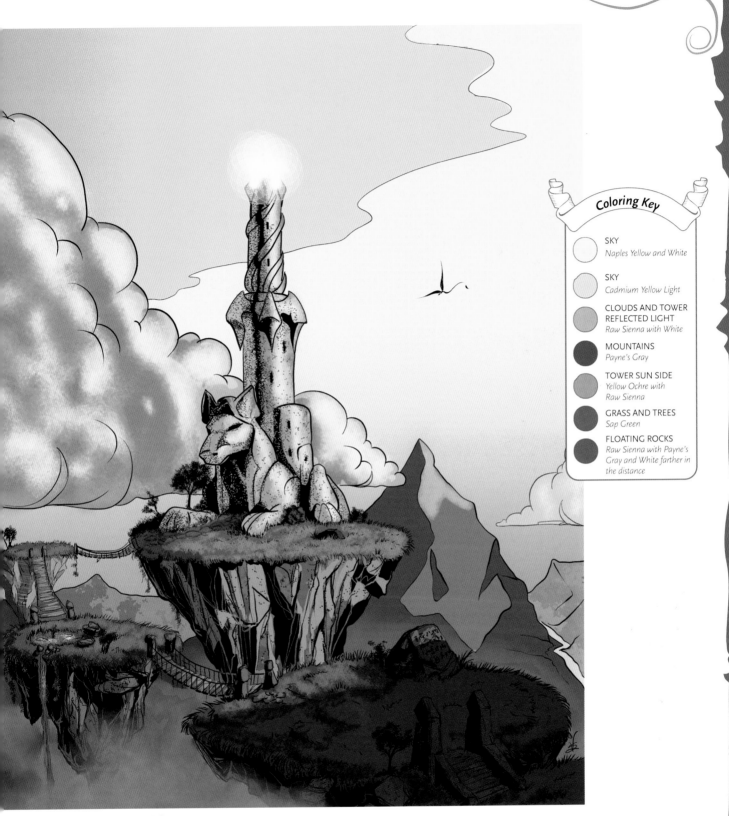

Coloring Key

SKY
Naples Yellow and White

SKY
Cadmium Yellow Light

CLOUDS AND TOWER
REFLECTED LIGHT
Raw Sienna with White

MOUNTAINS
Payne's Gray

TOWER SUN SIDE
*Yellow Ochre with
Raw Sienna*

GRASS AND TREES
Sap Green

FLOATING ROCKS
*Raw Sienna with Payne's
Gray and White farther in
the distance*

6 | **Add Color to Finish**
Vary the values of the different colors to show details within the different parts of
the scene. Use Payne's Gray glazes if you're painting traditionally or a semitransparent
black layer in a digital coloring program for the secondary cast shadows. You should end
up with a fully realized mysterious landscape that would make nearly any adventurer turn
back.

APPENDIX I
TEMPLATES FOR PRACTICE

Congratulations! You've made it through all the demonstrations. Use this appendix of finished pencil drawings for practice. Scan them (150–300 dpi) to practice digital coloring, or photocopy them on good paper to practice inking, watercolor, colored pencil or marker techniques. You might also copy them using tracing paper to get the feel of the contours and really hone those drawing skills.

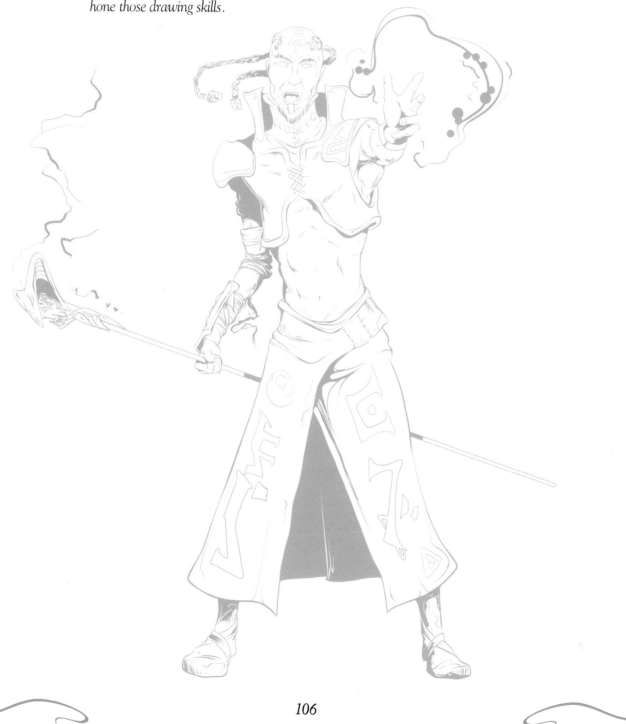

Dragon

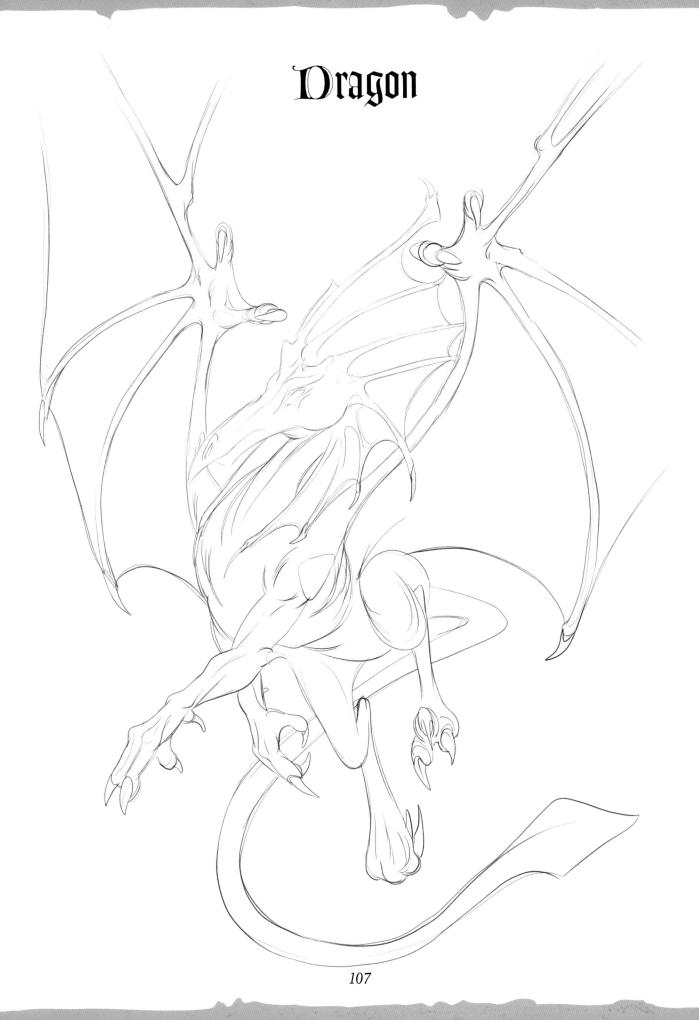

Demon

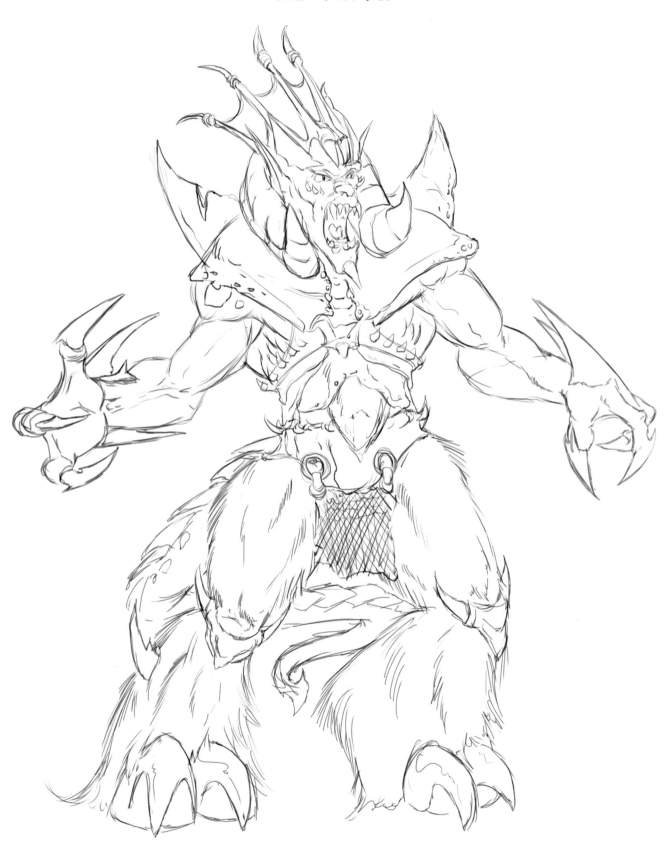

Griffin

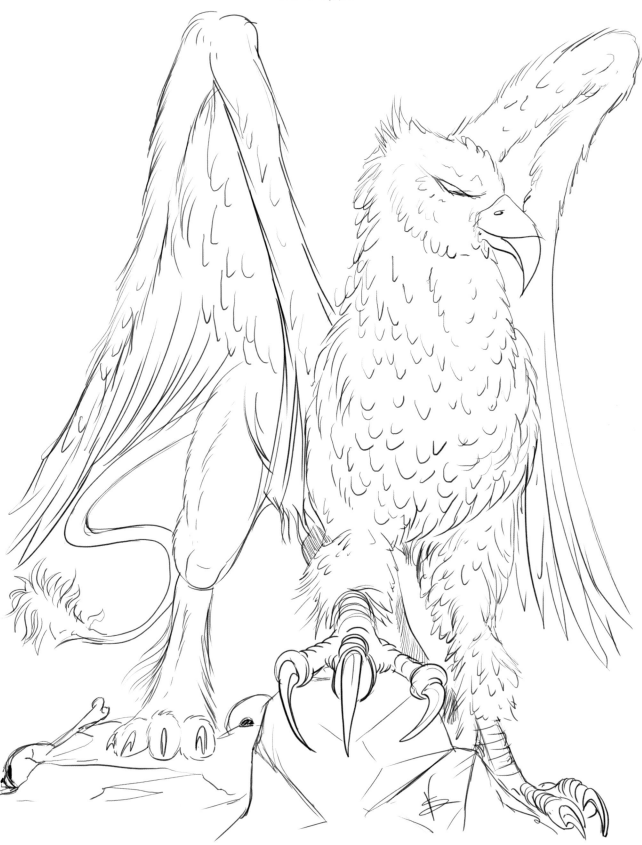

Goblin

Gargoyle

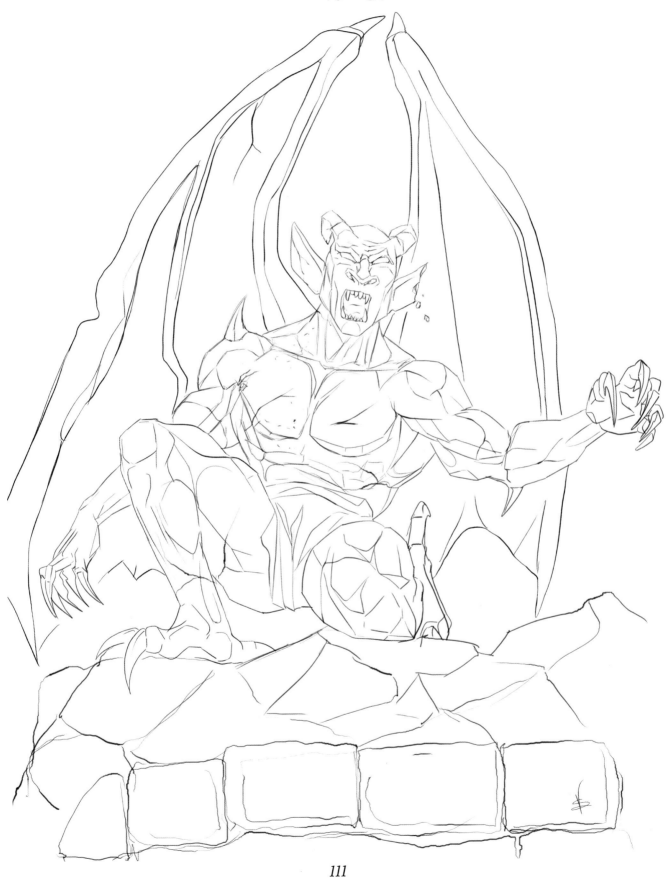

Warrior

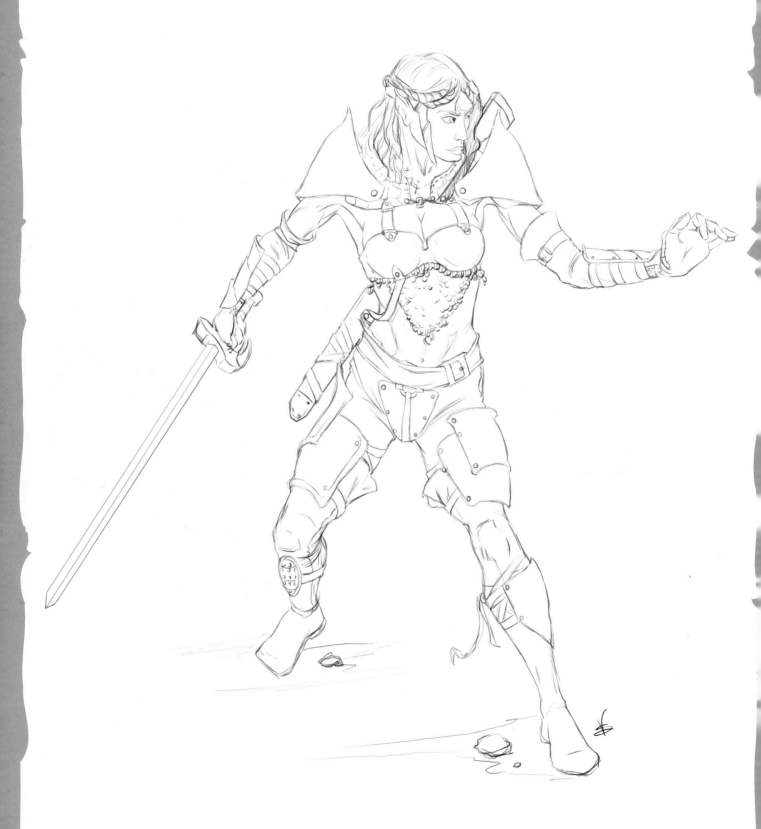

Knight

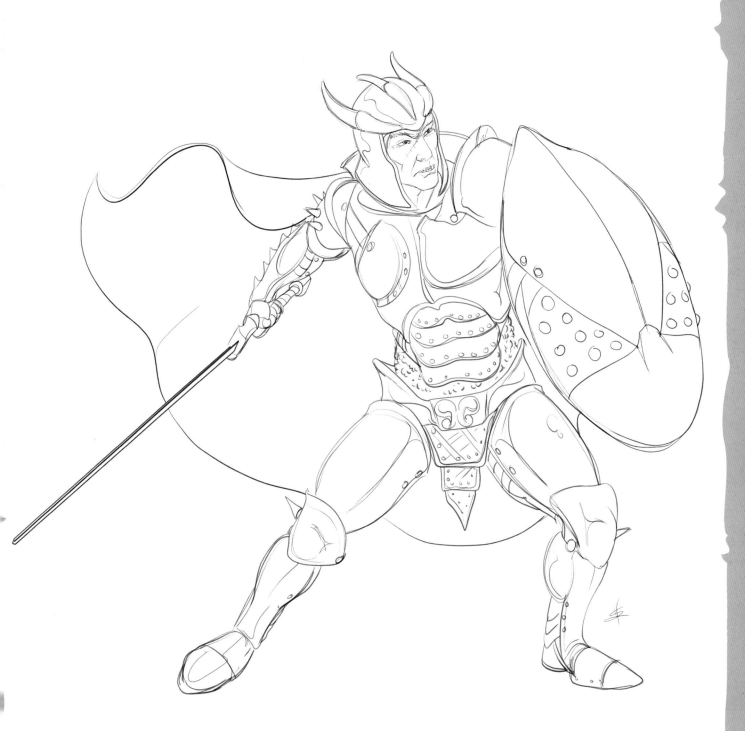

Princess

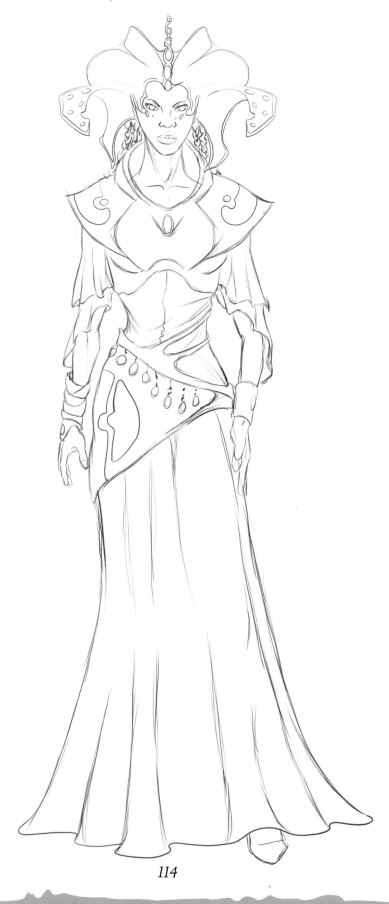

Sorcerer

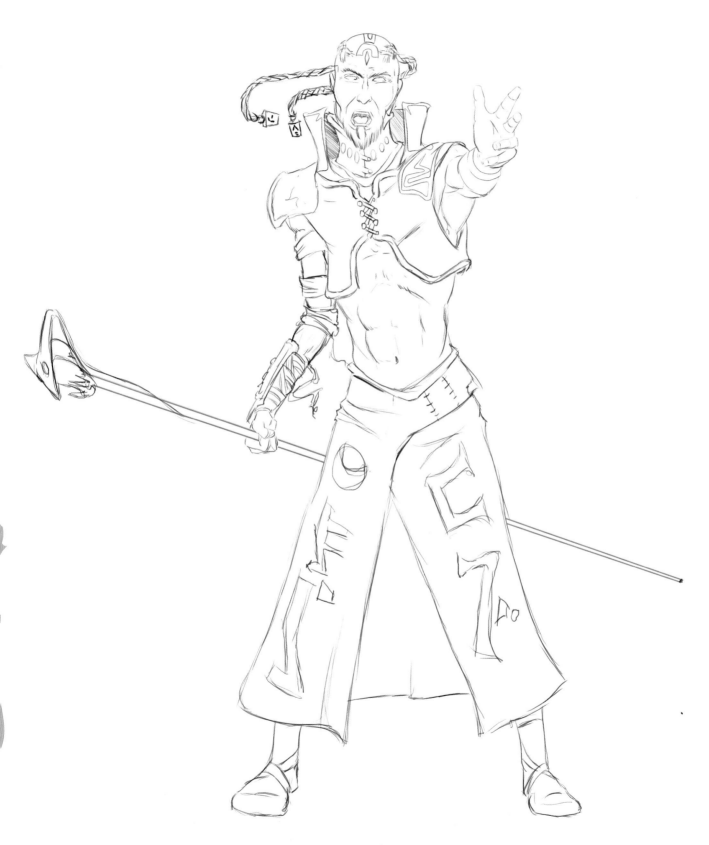

Faery

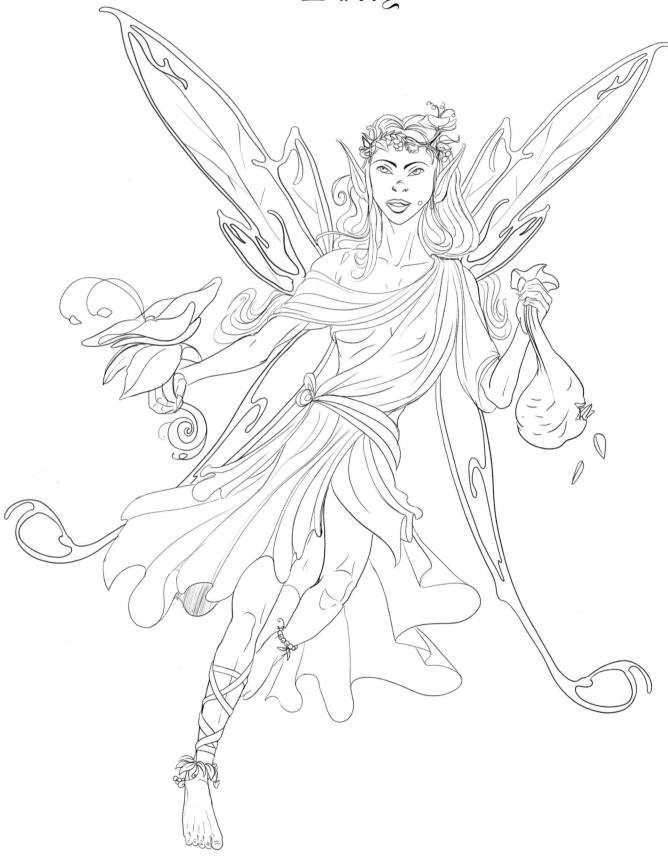

Castle

Castle Interior

Ruins

Village

Mysterious Tower

APPENDIX II
CREATION LISTS TO GET YOU STARTED

Not sure where to begin? Having trouble coming up with ideas? Grab some dice! This appendix consists of a series of charts meant to help you overcome any "blank page" dilemmas you find yourself in. Use the charts to brainstorm or for practice. You've already practiced many of the elements in the lists. There are some new things added as well to encourage you to stretch your drawing skills. So roll the dice, create a world. It's fun!

How it Works

The lists are all based on six-sided dice (the square ones). There is a separate set of lists for each portion of your scene: characters, creatures and settings. Use the lists all together to create a complete picture, or use them separately to help you create a portion of a scene. Roll the number of dice indicated on each chart to decide what to draw for that portion. Let's look at the Character Creation Lists as an example. If you roll:

3 for Race	2 for Class	7 for Action
5 for Emotion	3 for Attire	4 for Weapons

You've got an elvish knight meditating with a battle-frenzied look on his face, wearing a cloak and armed with a crossbow. Now, if you don't like something about this character (maybe you think a meditating elf should *not* look battle-crazed), change something. It's your creation. The lists are merely to get you thinking.

How to Read the Lists

Devotees of role-playing games have long used dice to decide just about everything from their characters' abilities to whether or not they win fights. To communicate how many and what kind of dice to roll when, they use this system. The first number plus the letter "d" tells you how many dice to use. The second number tells you how many sides the dice should have. So 2d6 means roll two six-sided die.

Canine or Feline

If you roll canine or feline for your character, it's up to you to decide what kind of canine or feline you will use for reference. If you're already working with a giant, human-type character, you probably want any canine paws to be large like a wolf's. If you're on your way to creating a fairy-type character, tiny poodle paws will work better.

CHARACTER CREATION LISTS

Begin your character creation by rolling 1d6 to decide how many characters will be in your scene.

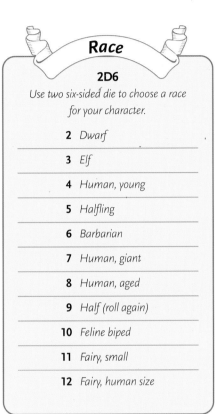

Race

2D6

Use two six-sided die to choose a race for your character.

2	Dwarf
3	Elf
4	Human, young
5	Halfling
6	Barbarian
7	Human, giant
8	Human, aged
9	Half (roll again)
10	Feline biped
11	Fairy, small
12	Fairy, human size

Class

2D6

Use two six-sided die to choose a class for your character.

2	Warrior
3	Knight
4	Prince/princess
5	King/queen
6	Thief
7	Sorcerer
8	Wizard
9	Ranger
10	Cleric
11	Stalker
12	Druid

Action

2D6

Use two six-sided die to choose an action for your character to be doing.

2	Ready for battle
3	Fighting
4	Surveying the scene
5	Praying
6	On the run
7	Meditating
8	Resting
9	Hiding
10	Goofing off
11	Casting (if magic-user or roll again)
12	Dying

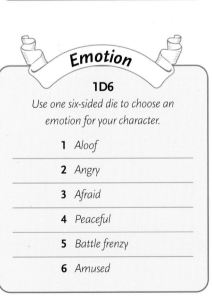

Emotion

1D6

Use one six-sided die to choose an emotion for your character.

1	Aloof
2	Angry
3	Afraid
4	Peaceful
5	Battle frenzy
6	Amused

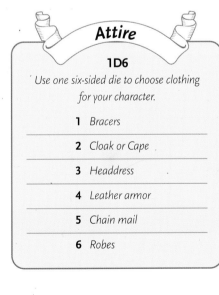

Attire

1D6

Use one six-sided die to choose clothing for your character.

1	Bracers
2	Cloak or Cape
3	Headdress
4	Leather armor
5	Chain mail
6	Robes

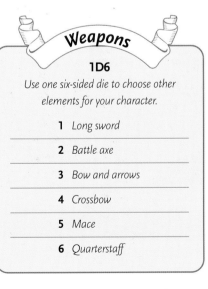

Weapons

1D6

Use one six-sided die to choose other elements for your character.

1	Long sword
2	Battle axe
3	Bow and arrows
4	Crossbow
5	Mace
6	Quarterstaff

CREATURE CREATION LISTS

Begin your creature creation by rolling 1d6 to decide how many creatures will be in your scene.

Head

2D6

2	Dragon
3	Eagle
4	Lizard
5	Goblin
6	Insect
7	Canine
8	Human
9	Skull
10	Demon
11	Rodent
12	Add horns (roll again)

Torso

1D6

1	Human
2	Insect
3	Armored (roll again)
4	Snake
5	Spider
6	Pick any animal

Arms

2D6

2	Tentacles
3	Human
4	Four-legged (roll leg chart)
5	Lizard
6	Insect
7	Skeletal
8	Add wings (roll again if you like)
9	Ape
10	Rodent
11	Canine
12	Sets of arms (roll 1d6 for how many)

Legs

2D6

2	Tentacles
3	Human
4	Canine
5	Goat
6	Insect
7	Cat
8	Skeletal
9	No legs, snake
10	Hawk
11	Lizard
12	No legs, gaseous form

Hands

2D6

2	Tentacles
3	Human
4	Talons
5	Canine
6	Insect
7	Feline
8	Skeletal
9	Severed, replaced with weapons
10	Pincers
11	Metal (roll again for type)
12	Each hand different, roll twice

Feet

2D6

2	Hooves
3	Human
4	Talons
5	Frog
6	Feline
7	Canine
8	Skeletal
9	Severed, replaced with metal
10	Lizard
11	Metal (roll again for type)
12	Each foot different, roll twice

SETTING CREATION LISTS

𝕹ow to decide the setting! Are your dice warmed up?

Environment

2D6

2 Swamp

3 Dark forest

4 Mountain pass

5 Rolling hills

6 Sunny forest

7 Windswept plains

8 Island

9 Floating island

10 Desert (sand or snow)

11 Isolated ravine

12 Jungle

Weather

2D6

2 Stormy

3 Rain clouds

4 Sunny afternoon

5 Clear dusk

6 Windy

7 Summer

8 Fall

9 Winter

10 Moonlit night

11 Spring thaw

12 Snowstorm

Unusual Things

2D6

(Roll on this list at least twice)

2 Lots of bones

3 One giant skeleton half buried (creature)

4 Glowing doorway

5 Structure is floating

6 Lots of webs

7 (1d6) Statues of (roll on character chart)

8 Treasure scattered about

9 If mysterious stone structures, they have gems imbedded

10 Fight scene between (roll twice on character chart)

11 Journey scene

12 One of the characters is wielding something magical (or casting a spell)

Structure View

2D6

2 Inside structure

3 On top of structure

4 In front of structure

5 Structure in distance

6 Entering structure

7 Closeup front of structure

8 Structure partially hidden

9 Structure covered in mist

10 Structure surrounded by rubble

11 Structure overgrown with foliage

12 Structure slightly sunk in ground

Structure Type

2D6

2 Palace

3 Ruins (roll again for type)

4 Castle

5 Village

6 Tower

7 Small hut or cottage

8 Abandoned (not ruined, roll again for type)

9 Tombs

10 Stone temple

11 City or village carved out of stone

12 Mysterious (roll again for type)

INDEX

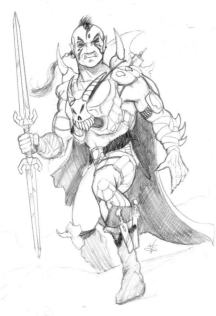

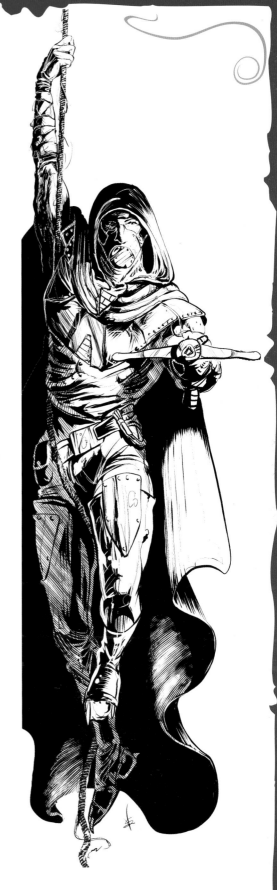

CHECK OUT THESE OTHER GREAT **IMPACT** BOOKS!